Native Plants
Native Healing

Traditional Muskogee Way

Tis Mal Crow

Native Voices
Summertown, Tennessee

Cover illustration by Stan Padilla
Cover design by Warren Jefferson
Back cover photograph by Gary Clark
Book design by Jerry Lee Hutchens
Illustrations by Chris Sewell
Additional illustrations (pages 60, 66, 71, 118, 121) by Stan Padilla and Jerry Lee Hutchens (page 56)

Special thanks to Dianne Clark for compiling and editing Tis Mal's work.

Native Voices

Book Publishing Company
P.O. Box 99
Summertown, TN 38483
1-888-260-8458
www.bookpubco.com

09 08 07 06 8 7 6 5 4 3

This book provides information about plants and healing as understood by Tis Mal Crow. The information contained in this book is not intended to be used as a substitute for medical advice, diagnosis, or treatment. Neither the author nor the publisher is to be held liable for any possible negative situation arising as a result of its use.

ISBN 1-57067-105-2 Printed in Canada

Tis Mal Crow.
 Native plants, native healing, traditional Muskogee way/Tis Mal Crow. p. cm.
 Includes index.
 ISBN 1-57067-105-2
 1. Herbs--Therapeutic use--North America. 2. Materia medica, Vegetable--North America.
 3. Indians of North America--Medicine. I. Title.
 RM666.H33 T57 2000
 615'.321'089973--dc21 00-046573

Printed on recycled paper

The Book Publishing Co. is committed to preserving ancient forests and natural resources. We have elected to print this title on paper which is 50% postconsumer recycled and processed chlorine free. As a result of our paper choice, we have saved the following natural resources:

BOOK
PUBLISHING
COMPANY

6.15 trees (40 feet in height)
1,794 gallons of water
1,051 kwh of electricity
15 pounds of air pollution

We are a member of Green Press Initiative. For more information about Green Press Initiative visit: www.greenpressinitiative.org

Table of Contents

Tis Mal Crow, Root Doctor 5

Introduction 6

Responsible Harvesting Versus Cultivation 10

Some Words of Caution 12

Gathering Herbs 15

 Getting started 15

 Doctrine of signatures 15

 Kofumu and communicating
 with plants 16

 Taboos 18

 Sacred harvesting of herbs 18

 Moon phases and harvesting 20

 Barking trees 20

 Gathering—looking in
 the right places 22

 Common sense and safety tips 22

 Hunting and gathering laws 23

 Buying herbs 24

Making Medicines 26

 Utensils 26

 Making teas 28

 Disposal of herbs 29

 Alcohol 30

 Making tinctures 30

 Cutting tinctures 31

 Making liniments 32

 Quick starting a tincture or liniment 33

 Making oils for internal use 34

 Making oils, lotions, and
 salves for external use 34

Transdermals—absorbing medicine
 through the skin 36
Capsules and pills 36
Other medicine delivery forms:
 smoke, steam, and
 spiritual fumigants 37

The Plants
 Sweet Leaf/Wild Bergamot 39
 Bloodroot 52
 False Solomon's Seal 56
 Echinacea 58
 Solomon's Seal 60
 Calamus 65
 Sassafras 68
 St. John's Wort 71
 Sweet Fern 74
 Tansy 77
 Tulip Poplar 80
 Violet 83
 Wintergreen 86
 Yarrow 89
 Birch 94
 Boneset 97
 Bull Thistle 102
 Catnip 106
 Cattail 111
 Cherry 116
 Dandelion 118
 Field Horsetail/Scouring Rush 121
Medicinal Plants Index 126
Index by Symptom and Usage 135

Tis Mal Crow
Root Doctor

Tis Mal Crow is a Native American of Cherokee and Hitchiti descent. He is internationally known as a native root doctor, herbalist, and artist. His artwork (including beadwork, dolls, and jewelry) has been displayed in galleries worldwide. As a root doctor and herbalist, Tis Mal has been teaching classes and workshops for over 20 years. He works with other indigenous healers and herbal groups internationally to promote the medicinal uses of herbs. Most of his adult life has been dedicated to teaching about and working for the conservation of the wild habitat needed to sustain the growth of medicinal herbs.

Tis Mal has been working with tribal elders since childhood studying the identification and medicinal uses of plants and traditional native root doctoring techniques. The information that he shares in his books and classes was passed down to Tis Mal by elders as it had been passed down to them for thousands of years. This is not new information or a new discovery but it is, to our knowledge, the first time that a book about traditional Native American healing techniques has been authored by a Native American practitioner. Other books that we've found on this subject are written by nonnatives with input from what they call "informants" who may or may not have firsthand knowledge of the uses and actions of plants.

Dianne Clark

THEY DON'T OWE IT TO US
WE OWE IT TO OURSELVES
WE CAN'T TAKE IT BACK FROM THEM
THEY DON'T HAVE IT

IKJOSHAWAY
THE SPIDER

Introduction

The type of medicine described in this book is practiced by the Eastern Woodland root doctors. Early Europeans called them conjurers and jugglers. Hollywood gave them the hokey name "medicine men" and later in the 20th century the term "shaman" began to appear. In fact, each culture has their own name for a practitioner, and in the Eastern Woodlands the name is often root doctor. That is how I refer to what I do.

Our medicine way teaches the interconnectedness of ALL things, and it celebrates and respects all living things. It teaches us to harvest plants with respect by taking only what we need. It teaches us to give back and to live in balance with nature.

Before European contact, most of the information in this book was known to the common person. But, after many years of genocide and

forced assimilation, the people had to hide this knowledge underground. It was kept alive by select people and families whose job it was to protect and preserve the information and to train new practitioners so that the knowledge would survive. And through many years of oppression, it has survived even the reservation system, forced cultural assimilation, and the taking of our children and placing them in boarding schools where they were forbidden to speak their own language or learn their own cultural traditions and religions. It has survived even as the dominant culture has discredited our science and medicine as being mythology, while at the same time, they are searching the rain forests of South America and the jungles of Africa for plants that will provide a marketable miracle cure.

It has only been as recently as the late 1970s and early 1980s that a revival of the many and varied Native American cultures has come about. This resurgence has brought both the spotlight and the microscope of the world to our doors. Everyone is interested in Native Americans, in what we do, how we do it, what we wear, and when and why. This has brought up much debate in the native community about if and when the details of our culture should be shared. There are deep divisions of opinions that are debated daily in private councils, public debates, and around the dinner tables of families across the country.

Nothing invites a more heated debate than the ideas of sharing what is considered sacred information, such as religious ceremonies, or sharing information about the medicine ways. I have often been criticized for teaching nonnatives about the medicinal uses of plants. My response has always been that I was taught to use these plants on sick people, not red people or white people. God gave these plants to all people. And I firmly believe that we need to share this knowledge of plants as medicines in order to save the plants. If we save the plants, we save ourselves. I think it would be a tragedy to keep this knowledge in secret, because when a plant becomes extinct, then the medicine is lost and the secret becomes useless.

This push to extinction is already happening with Ginseng, Goldenseal, *Echinacea tennesseensis*, and now Black Cohosh. Each has been discovered by consumers and exploited by commercialization as fad herbs to the point where they are facing extinction in the wild. Our willingness to open up and release more of what has been secret knowledge may help people realize that there are many alternatives to these popular herbs and that often the alternatives are better suited to specific symptoms.

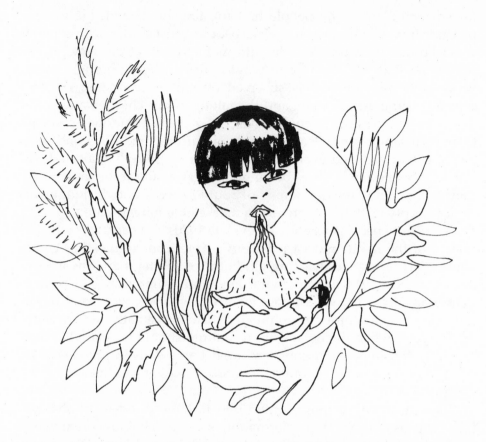

Black Cohosh is a prime example of this overuse and abuse. It has been discovered by drug and herb companies and is being sold commercially as a cure-all for menopausal symptoms. In fact, Black Cohosh should be used with caution, because it can cause menstrual flooding in some women and if taken incorrectly can actually cause severe cramping in the abdomen and in the legs and back. It can also lower the blood pressure and cause nausea. It should never be used by women who are pregnant or lactating, or if you already are anemic or have low blood pressure.

In some cases, Black Cohosh is a very good herb, but in my classes I discuss over fifteen plants that address the specific symptoms of menopause, PMS, hormone imbalances, and other problems related to menses. For example, Motherwort works well for hot flashes and mood swings. Nettles make a good all-around tonic that is high in minerals and can be used as a food, tea, or tincture. Seaweed and Boneset are also high in minerals for those concerned with osteoporosis. Wood Betony, Ginger, Motherwort, and Skullcap are all

good muscle relaxers and nerve tonics. Red Clover and soy are high in phyto-estrogens. No two women have quite the same problems with menses or during menopause, and no one herb should be burdened with treating all of them.

It is quite a burden too. Black Cohosh is being taken from the wild at a rate of 300,000 plants per week (that is 15.6 million plants per year) according to Diane Don Carlos, project manager for the National Center for the Preservation of Medicinal Herbs (NCPMH) in Rutland, Ohio. In the depressed economy of Appalachia where its habitat is already threatened by logging, it is being gathered from the hardwood forests by the pickup truck-load and sold to commercial buyers for as little as $1.25 per pound as of 1999. It takes about 25 mature plants to make 1 pound of the dried roots that are used in medicine. When the root is harvested, the plant is dead, and very few who gather plants for this type of commercial resale are as concerned with reseeding as they should be.

Goldenseal is another case of a plant being harvested to extinction because of its popularity. Again, gatherers go for the root of the plant and kill it because that is the part wanted by commercial buyers. This is even more senseless, because the mature tops of the plant could be used instead, and the roots could be left for regrowth. For every legitimate use of the Goldenseal root, the leaf and stem can be safely substituted and will yield the same results. But only when informed consumers press for this change will the demand for goldenseal root decrease, and the plant will be allowed to recover in the wild.

Responsible Harvesting
Versus Cultivation

In every class, I try to teach responsible harvesting techniques in the wild—simple things like never taking the root of the plant until the plant is fully matured and producing seeds. I also stress waiting until late fall to be sure the seeds are mature and falling to reseed the patch and never taking more than you actually need. My basic message is that we need to stop cutting down the woods, because the plants we are killing to extinction are more valuable than gold if they are responsibly maintained as renewable resources.

Cultivation has been offered as a solution to the problem of over-harvesting in the wild. Having used herbs and observed their actions for over twenty years, I find that those from the wild are superior to those that are cultivated. I think that the power of a plant is enhanced when it is allowed to grow freely where it chooses to grow. The nutrients that are essential for its health come from the soil that is fed by the other plants and animals that surround it in the wild.

Again, consider the case of Black Cohosh. According to information published by the National Center for the Preservation of Medicinal Herbs (NCPMH), commercial cultivation of Black Cohosh is basically nonexistent. It takes 1 full year for the seeds to germinate, and commercial attempts at seed germination usually offer no more than a twenty-five percent yield. Then, it takes 3 to 4 years for the roots to grow to be ready for harvest. Now, I was never very good at math, but with the help of a calculator, here is what I came up with just for Black Cohosh:

At 300,000 plants per week, the current volume of harvest means
15.6 million plants per year. To get this many plants,
62.4 million seeds need to be planted each year if only
25% germinate.
62.4 million plants growing before the first harvest, and it takes 4
years to mature.
1,433 acres of new cultivation if each plant needs only 1 square
foot to grow,
+ enough room to plant 62.4 million seeds per year and allow
them to germinate.

Of course, this 1,433 + acres of new cultivation will probably come from cutting down a hardwood forest that, if left alone, would produce a wider variety and a higher quality of herbs. It seems obvious to

me that cultivating Black Cohosh the way you would corn does not make sense economically or environmentally, even if I thought that the resulting herbs would be comparable to those harvested in the wild. But, as a realist I know that our wild ecosystems cannot survive for very long when we strip them of billions of plants each year. Thanks to efforts of the NCPMH and other herbal preservation groups around the world, cultivation studies are underway to help us find a balance once again between keeping our herbs as wild renewable resources and meeting our demands as herbal consumers. But money and manpower for these studies are limited, and time is running out for the plants very quickly.

As a Native American, I believe that things will come full circle. Wouldn't it be ironic if the eastern woodlands that were so ruthlessly cut down over the past 200 years for logging and to be put under the plow were suddenly more valuable as a hardwood forest where the herbs are responsibly harvested?

Some Words of Caution

This book is not a medical guide

This book is not a medical guide and should not be used for medical advice or self-medication. Any medical problems should be addressed by a trained practitioner. Never take an herb because you think you might need it. In most cases a trained practitioner will find other associated symptoms that you may be overlooking. A responsible practitioner will never treat themselves, their family, or close friends and relatives. By being close to the patient, you are not objective and often not rational in a crisis.

Warnings, drug interactions

Medicinal herbs should be taken with the same precautions as prescription medicines, with special attention to possible interactions between herbal preparations and interactions with herbs and other medications, including over the counter drugs. Labels like "All Natural," "Organic," and "Herbal" do not mean that there are no side effects, no drug interactions, no diet restrictions, or no dangers. Here are some examples to consider:

Overdoses of Echinacea can cause permanent liver damage.

Goldenseal, when taken in recommended dosages, can kill you if you are taking some prescription heart medicines or blood thinners.

Goldenseal when taken in large doses can kill you. It lowers the blood pressure and can lower it to the point of death.

There is an underground myth that taking Goldenseal will make you test clean on a drug test. This is false. I get 2 to 3 calls each year from people near death who have fallen for this dangerous lie.

Remember, even a small amount of Water Hemlock will kill you in minutes. It is "All Natural," "Organic," and "Herbal."

Some basic science

When you take an herb, you are taking a chemical compound. If you use heat (making a tea) or alcohol (making a tincture) or digestive juices (eating or drinking), you begin to break down the plant and release the chemicals. Some of these chemicals can join or combine into new chemicals. In your body these chemicals break down again and release energy. They can release either good energy (healing powers) or bad energy (side effects).

Never take any herb unless you research both the positive and negative effects. For example, if you are thinking about taking St. John's Wort for depression, you should know that it makes you very sensitive to sunlight. Therefore, if you are fair skinned, spend lots of time outdoors, have a family history of skin cancers, or live in a sunny climate, you should look for alternatives.

Choosing an herbal practitioner

When choosing an herbal practitioner, you need to use some common sense and research their qualifications just as you would any health care professional. Many of the best herbalists in the country do not hold any degree or special certificate, and having some paper proof is a relatively new concept to people who have been practicing for decades. Just as with doctors of Western medicine, a degree does not make a good doctor.

Ask lots of questions about what type of herbalism they practice. Each indigenous culture has their own form of healing, and then you have broad categories like Western herbalism, Chinese herbalism, or homeopathy, which is like a combination of chemistry and herbalism.

Investigate your options and then investigate the person. How long have they been practicing, and how did they learn what they know? Do they really know what they are talking about, or are they reciting from an herb company's sales brochure? Do they ask questions about your condition and your medical history, or do they offer to sell you a pill based on 1 or 2 symptoms that you mention? Always interview several candidates and compare your options before you become sick and your judgment may be clouded.

Beware of mixing herbs

Unless a mixture is prepared and recommended for you by a trained professional, do not trust it. When you mix 2 herbs, you are mixing chemical compounds. (Refer to the previous section on "Some basic science.") Many herbs can interact with other herbs and produce an effect that would not be expected from just studying the effects of the individual ingredients. It's like the old science class experiments where they have you mix baking soda and vinegar to create some noxious gas that you didn't expect.

An herbal example shown in this book is a mixture of Birch, Sassafras, and Ginseng that is used for muscle rejuvenation and regrowth. This use is not indicated by looking at the specifics of each of these plants in most herb books. Also, this example of good results from a mixture is not typical.

I really worry when I see books that list 5 to 10 herbs that are good for flu symptoms and tell you to pick and mix the ones that you like best to make a tea. Often, overlapping positive effects can cause an intense overreaction or an overdose effect.

An example of this is mixing Butterfly Weed (a.k.a. Pleurisy Root) and Goldenseal. Butterfly Weed is used for pleurisy, water retention, pneumonia, and fluid in the lungs. Goldenseal has a mild antibiotic effect and is commonly used for colds, flu, and pneumonia to help dry up congestion. When combined, they intensify the effect of drying up unwanted fluids and begin to dry up all of your fluids. You can't drink enough water fast enough to replace your fluids and will begin to dehydrate. Your blood pressure will also drop dramatically. If you are lucky, a trip to the emergency room might save your life. Both, severe dehydration and a dramatic drop in blood pressure can kill you.

Accelerators

Another good reason not to mix herbs is because of a special group of plants that are known as activators or accelerators. When used properly, an accelerator is added to a target herb in minute doses of about 1 ounce accelerator to 1 quart of target herb tea or tincture. The effect of an accelerator is to increase the relative potency of the target herb without increasing the dosage. Usually, this is done by increasing the absorption of the target herb into the system. If you accidentally mixed an accelerator with its target herbs in a higher proportion, it could be like taking ten to twenty times the dose that you thought you were getting. This could be fatal.

Two plants that I talk about in this book are accelerators. Calamus root is an accelerator of white-flowered medicines and white-rooted medicines. Violets are an accelerator for green medicines. I will mention a third accelerator, because it has become a very popular herb. Ginseng is an accelerator of red-, yellow-, or white-rooted medicines. If you take any form of Ginseng products, be sure you do not mix it or take it at the same time as other herbs that it may accelerate.

Gathering Herbs

Getting started

Finding herbs in the wild can be tricky, because plants have a way of hiding from you and other plant predators. Many herbs grow among other plants that look very similar, and some of these look-alike plants can be poisonous or cause rashes. This is what I mean by a plant hiding from you. It is one of their defense mechanisms to hide among plants that bugs and animals can't eat.

Do not touch a plant until you have made a positive identification. Most experienced plant gatherers have 1 or 2 favorite field guides that they carry in the woods at all times. If you are not 100% sure about the plant identity, then do not pick it.

A good field guide will have pictures, line drawings, and detailed descriptions of the plants, how they grow, and where they grow. The photograph is probably the least reliable for identification because they can be deceiving depending on lighting, clarity, and camera angle. Detailed line drawings and descriptions will often better emphasize any unique points of identification.

For beginners, check out your local area and state parks for herb clubs, nature walks, or arboretums that offer guided tours. Take along your field guide and get up close to the plants and take some notes to jog your memory later. Once you get out in the woods, it will be easier to recognize the plants you have seen before.

Walking in the woods with other experienced people is a great way to learn too. I was taught herb identification by walking through the woods and gathering plants with my teachers. I didn't have access to field guides and arboretums, but I was lucky enough to be around a group of older people who had at least 500 years of combined experience in the woods that they enjoyed sharing with me.

If you are an experienced gatherer, seek out local groups or form one of your own where you can share your knowledge with others. It is a great way to spend an afternoon and get to know new people and plants.

Doctrine of signatures

While I was learning the medicine ways of my people, I had several teachers. But among them, there was always the consistent message that plants are sacred beings and that each plant was put here by the Creator for a purpose, just as we were. Each plant was

assigned special problems and diseases that it would be able to cure. The Creator took pity on us and our ignorance of the plants.

First, we were shown 7 basic medicines to give us a head start. We call these the Seven Sacred Medicines. Some of these I can and will talk about in the text under the specific plant headings, such as Sweet Leaf or Wild Bergamot. Others are still kept secret. From these plants, we learned to understand the signs that the Creator had left us to help learn the plant uses and to easily identify them.

The Creator had designed plants so that each one would have markers to indicate its uses. As a student, I was taught to read the plants just like you would read a book. I was taught that by learning to observe their shape, color, texture, patterns in leaf, stem, or root systems, their smell, taste, or the climate and location where they grow, you would know how to use them.

Many years later, when I began to teach about plants through my own classes, I ran across a discussion of "the doctrine of signatures," in an old herb book. I asked around and did a little investigating. I found out that the name for this type of plant identification is European in origin, but that indigenous peoples from around the world have similar systems of identifying the uses of plants.

When I started working with other indigenous healers from around the world, we began sharing plants that were unique to our areas. It became a game to bring in a new plant and see how many of the plant's local uses could be determined by the other people through the doctrine of signatures. In this book, I use this name to present the signatures that I use to identify a plant's uses according to my culture.

Kofumu and communicating with plants

As a root doctor, I have been taught that plants are sentient beings. They not only react to heat and light, but they know your intent and are capable of communicating. Plants communicate with each other, with other animals, and with humans. Unfortunately, most humans have forgotten how or were never taught to listen.

If I lost your confidence in this last paragraph, I'll refer you to a book that I discovered several years ago, *The Secret Life of Plants*, by Peter Tomkins and Christopher Bird, (Harper and Row Publisher, 1973). This book provides information that you might find enlightening about scientific testing and discoveries made by scientists from many different disciplines and cultures. I think their results will convince you that there is more to these plants than meets the eye. Maybe it will inspire you to try the communication called "Kofumu" and talking with your plants.

When I was a young student, my elders taught me to practice a slow rhythmic breathing technique and to clear my mind of all conscious thoughts. While in this relaxed state, you visualize a fire coming from your solar plexus that gets larger as you inhale and dims to an ember when you exhale.

After much practice at reaching this meditative state, I began to learn to communicate with the plants around me. It is not an audible sound but a case of knowing the message or the answer. I can ask questions and they can offer advice or just have a chat. When I need to find a plant for medicine, I ask them and then will get a picture in my mind and I can walk right to them. This works for me even when the plants are under the ice and snow. They will direct me to a spot and when I dig through the snow, I will find the plant that I need. In the coldest part of winter, I was directed to dig in a snow bank where I found the plant that I needed, healthy and green with flowers blooming.

I asked the plants once what this type of communicating was called, and they told me "Kofumu." I asked if this was an Indian word, and they told me no, that this is a plant word. I have often asked elders if they know this word in their native language, but I have not found it yet in any Native dialect. I never asked them how to spell it, though, so the spelling is mine. I just spell it like it sounded.

I don't claim to understand how this works but only know that it does, and I have been able to teach some other people to do this. Usually, the hardest part is first accepting that it might work for them and then being able to completely clear their minds for any length of time. With lots of practice on your part, you will find that many plants are quite chatty; others are more reserved but will answer your questions if you are interested and respectful.

I also know that plants have pity on sick people and animals and want to help them. Even if you are not trained at listening to them, they are listening to you. They will seek you out when you need their help. Plants that move into your yard or garden are there to help you. So, instead of killing off those "pesky weeds," you should investigate what they are used for and how.

The amazing part is that the plants show up before the disease does. They are there and ready by the time you are sick. I can observe or inventory the plants in your yard 1 year and then come back the next year and compare the differences. From this I can tell you what sicknesses will come this year and in what order they will appear and the severity to expect. The sickness can appear in you, your family, a visitor, or someone who comes to you for herbs. I can't tell who, but sometimes the plants will tell if you ask.

Taboos

Harvesting herbs and making medicines from herbs should be approached as you would a sacred ceremony. The plant should be considered the vessel chosen by the Creator to deliver the medicine to you and should be treated with the respect it deserves.

You should never drink alcohol or be under the influence of narcotics when you are dealing with the plants and making medicines. You should be in a good state of mind. Don't use profanity and leave any anger or bad feelings behind.

Women today are taught to use hygiene practices and products that free them to participate in almost any activity during their moon time, when menstruating. But it is a taboo found in most cultures that during their monthly period, women should not participate in gardening or food storage such as canning, and they are usually forbidden to attend sacred ceremonies during this time. Also, women should not gather plants or make medicines while they are menstruating.

I have seen medicines go bad, even alcohol-based tinctures, after being handled or prepared by menstruating women. And I have had women become sick and have bad reactions to the plants when they try to ignore this taboo or try to trick me and attend a workshop where we are making medicines. This warning is for their protection too. I always ask women who are helping me before we start to gather or handle plants or make medicines if they are menstruating. This is a good practice if you have friends that help out or if you go gathering in groups. Don't be embarrassed and be firm that they must not help if they are menstruating.

Sacred harvesting of herbs

Sacred harvesting begins before you even leave home. It begins with your attitude. You must approach the plants with respect and without anger or ill will in your mind. Remember that the plants are sentient beings, and they know your intent. Even if you aren't listening to them, they are listening to you. Tell them that you are here to gather medicines to help a sick person or animal, and ask for their help in finding the medicine that you seek.

When we collect plants, we leave an offering of either tobacco or cornmeal as a sign of respect, a form of thanks, and a way to put something back into the earth where we have taken something. Tobacco and corn are sacred plants that are used by most Native American cultures in some ceremonies and when making an offering of respect. Tobacco is commonly used in loose form, like pipe tobacco, or you can cut your own from a dried hand of tobacco. Corn is usually used in a

pure cornmeal form. Don't use cornmeal mixes; use only ground corn or dried corn kernels.

If I am going out to gather plants, I will make a small offering before I leave home. Offerings should be put next to a tree or under a bush where they won't be disturbed or stepped on or over. Use a table-spoon or less of tobacco or cornmeal, and sprinkle it over the ground as you are thanking the plants and asking for help in finding the medicines that you need.

Plants, like people, usually grow in family groups. When you spot a plant that you are seeking, stop and take a good look around you. In a family patch you will find the new, small plants that are the babies, the medium-sized parents, and the largest and most mature grandparents. If you only find 1 or 2 plants and there is no variety of sizes, then move on to another patch. By leaving these plants until later in the season or next year, you will let them establish the family patch that you can always revisit or harvest later.

When you find an appropriate family group, seek out the largest of the grandparent plants. These are the elders and should never be picked. Instead, leave an offering with them for the family members that you need to take.

Take only what you need, and be sure to take a variety of plant sizes. Consider them like family members and never take all of the plants from one generation. Be sure that you leave some of each generation. The small plants rely on the mature plants to teach them how to survive.

To harvest the top part of a plant, use a sharp pair of scissors or a sharp knife that will cut through the stem without crushing or bending the remaining stem. You should leave as much of the stem as possible or just take the top and let some of the lower leaves or side stems remain. This gives the plant a chance to recover and continue growing. If you are gathering late in the plant's season, shake off any seeds and cover them lightly with dirt.

Harvesting roots will usually kill the plant. Some exceptions are those plants that have segmented roots, like Solomon's Seal, Cattails, and False Solomon's Seal. If you dig these plants carefully, you can salvage the part of the root that is attached to the stem and replant it after harvesting the rest of the root. Ginseng develops a spare root that is located at the top of the root system near the growth rings. This spare root can be replanted after the main root is harvested and the plant will keep growing. When harvesting other roots, check the plant top for seeds that can be planted before you leave.

When digging for roots, be careful to do as little damage as possible to other roots and plants. Use your hands to separate tangled root systems, and use the smallest digging tool that you can. For example, in soft ground around hillsides and banks, your hands or a small garden spade will work best. In harder ground or for deeper root systems, you may want a short-handled pick. Shovels usually make a hole that is too big, and they are hard to use in tight places.

In general, have respect for the other plants in the area, as well as the plants that you are harvesting. Take care when walking, picking a place to rest, or harvesting to leave the place in the same shape or better than you found it. Don't leave holes where you have dug roots and replant anything that you dig up or pull up by mistake.

Never wander idly through the woods and break off tree branches and weed tops. To a plant, this would be like a stranger coming up to you on the street and pulling out some of your hair. Just as this would make you mad, a plant sees your actions as complete disrespect and inflicting pain for no reason. If a plant or tree is blocking your path, then go around or gently hold them aside while you pass.

Moon phases and harvesting

In science class we all learned that the moon's gravitational pull is what makes the ocean's tide get higher and lower. When the moon is full, the tide will be higher; when the moon is new or dark, the tides will be lower. The same thing is true for water levels in lakes, rivers, and in the ground and also the water levels in plants and trees.

With this life-giving water comes the nutrients that the plant needs to grow and the power of the plant and the strength of its medicine. When grandma told you to pick beans when the moon was light and dig potatoes when the moon was dark, she wasn't just repeating an old wives' tale. She was teaching you the science of moon phases and their affect on plant growth and strength.

To gather plants according to the moon phases, gather the top parts of a plant (including the leaf, flower, stem, and tree bark) during the time when the moon is closely approaching full. Likewise, roots are gathered when the moon is going down and it is closer to the new moon phase.

Barking trees

Removing the bark from a tree or log is called barking. For personal use, you should never need to take the bark from the main trunk of a living tree. If you are inexperienced and not very careful, barking a tree trunk could kill a tree. There are many options that we will cover here.

First choice is to check around for people who buy or sell wood for fireplaces. You will need to know what you are looking at and be able to pick out the correct bark from the wood pile, but the tree has already been cut and the bark will loosen or fall off when the wood is split for burning. In the north, this is a good source for Birch bark.

A second choice is to look for logging companies or sawmills in the area. Once again, the trees are already dead and it would be nice if some good could come of this. If you ask nicely, most operators are glad to let you haul off as much bark as you can take. In the east, this is a good source for Tulip Poplar and White Oak barks.

Your last choice should always be to go to the woods for bark. If you must, look first for recently fallen trees or larger branches that get blown off in storms. Older fallen logs and branches may be too decayed to be useful for medicines. Check them out first by removing a slab of bark and checking it for decay, termites, worms, and other bugs. If it doesn't look fresh, then pass it up.

If there is nothing usable on the ground and you must use part of a live tree, then use a branch and not the main trunk. Do not cut the tree down and do not cut the branch off of the tree. If the tree is tall and you are not an experienced tree climber, then take a ladder with you and someone to hold it for safety. The ground will probably not be nice and level.

The bark on branches is usually thinner and easier to remove, but it is also easier to cut too deep and kill the branch. Knowing how deep to cut is the trick of barking that comes with experience. You need to cut deep enough to get through the inner bark but not so deep that you go beyond this point.

Do not girdle the tree or branch. This means do not cut the bark all the way around the tree or limb. It is better to cut smaller strips of bark from a branch and don't take all of the bark from the whole length of the branch. Take only strips that are 4 to 6 inches long and no more than ¼ of the width of the branch. If I recommend a 4 x 4 inch piece of bark for medicine, you do not need to have this as 1 piece of bark in this exact size. It is better to take several smaller pieces from a side branch that will yield the same total amount of bark.

Carefully cut 4 lines in the bark, 2 going around about ¼ of the branch, and then connect these with 2 cuts along the length of the branch. A very sharp knife with a locking blade will give you better control and allow you to better judge the depth you are cutting. I do not recommend using saws for this because you have less control and the small cuts are more difficult with a saw.

When the cuts are made, you should be able to begin to lift the bark off by starting at one corner and working down the longer side to loosen the bark from the inner wood. Do not gouge into the inner wood by prying it with the knife. Any puncture of the inner membranes can cause the tree to bleed to death from loss of sap. If you need more bark, continue on the same branch and on the same side of that branch whenever possible.

The easiest time to bark is with the major sap runs in the spring to early summer. Some years barking is possible for several weeks, and some years only for a matter of days or not at all. When the moon is up and the sap or water levels are up, the bark will release from the tree easily, sometimes with a popping sound. The fluids are running between the bark layers and the inner membranes and this moisture actually helps to separate the bark from the tree.

If the timing is not right, the bark will not come off. It holds tightly to the tree and usually couldn't be pried off with a crowbar. When you face this situation, there is no forcing the bark loose. You will need to wait until another time because any tree that you try will be the same. This happens when there is a long, dry weather period and the trees do not have sufficient moisture for the year.

Gathering—looking in the right places

Pay close attention to where a plant grows. Check your field guide first, and note the description of where the plant grows and what type of soil or sun exposure it likes. Don't go into the woods if the guide tells you that the plant likes the morning sun or that it grows in disturbed ground. These are open space descriptions. Disturbed ground is found near populated areas, usually where there has been excavation the year before, old logging sites, newly cleared land, or plowed land that is now unused.

When you find a plant for the first time, make a few notes of your own. Notice what grows around it. Are the trees mainly oak or pines? Are you in the middle of a berry patch or a poison ivy patch? Is there a lot of underbrush or are there thick trees and very little direct sun? Look for a similar environment to find the plant again.

Common sense and safety tips

Do not gather plants from roadsides. It is tempting when you drive by a beautiful specimen just waiting for you next to the road. Stop and think. There are pollutants from traffic such as lead from exhausts and seepage from asphalt and tar. In moderate to cold climates, there are salt and de-icing chemicals. Also, many local governments and private

22

land owners use chemical sprays along roadsides, railroad tracks, and fence lines to clear weeds. All of these infiltrate the ground water through runoff and pollute the surrounding ground and plants.

Remember, water runs downhill and will bring contaminants along with it. Always be aware of what is uphill from your plants. Ground water and plants can be contaminated from septic systems, lawn, garden, and farm chemicals, herbicides, pesticides, detergents, cleaning products, and fossil fuels, just to name a few. Also stay away from golf courses, athletic fields, campgrounds, and housing developments that use chemical lawn care products.

Be aware of any local business or industry pollutants in local streams, rivers, or ground water. They may be within acceptable EPA standards, but you may not want to eat many of the things that the EPA finds acceptable.

Check out your area for both current and old legal dumpsites, and drive around the area to check for any illegal dump sites. Often in rural areas you will find places where someone has dumped their garbage, old furniture, and appliances or old cars and tires.

I also stay away from high voltage electric lines and power plants. They are suspected of having effects on plant and animal life. I'd rather be safe than sorry.

Hunting and gathering laws

The plants that I discuss in my classes are those that have been used by my people for many generations. The information is presented as I learned it and does not take into account any laws that have been passed to protect the specific plants. It is your responsibility to know your laws and abide by them. Seeing a plant mentioned in this book does not mean that it is legal to gather it in all places.

Before you go into the field, know the local, state, and federal laws that protect many plants. For example, Ginseng can only be harvested in the wild during a specific season, and this could be changed at any time. Some states have protected flowers and plants that can't be harvested at all. The federal government also has a list of plants that are considered endangered species and can't be harvested in any state.

Know your local hunting laws and seasons before going into the field. You don't want to get shot by someone who mistakes your ponytail for a squirrel. Avoid heavily wooded areas or thick underbrush during hunting season. Always wear colors that are bright, and make enough noise to be recognized as a human. Never wear anything with fur or camouflage patterns. You want to be noticeable.

23

Unfortunately, most fall hunting seasons are also the best times to gather roots, berries, and nuts. This is also the favorite time for bears, wolves, and other wild animals to gather roots, berries, and nuts. Hunters know this too and are drawn to the same places. Be extremely cautious just after daybreak and just before dusk or when visibility is limited by fog. These are also the times favored by hunters.

Buying herbs

If you need a plant and can't find it in the wild or it is out of season, check your local herb stores for availability. Choose an herb store with the same attention that you would use to choose a practitioner or a pharmacy. Get to know the staff and ask where they get their herbs. If they only sell bottles of pills, I would find another store. My first recommendation is to gather the plants yourself. If this is not possible, then choose to buy bulk herbs rather than pills whenever you can.

A good herb store will offer bulk herbs. They should be labeled if they are wild-crafted, organic, or cultivated. Buy herbs and roots in the form that is closest to whole; either whole leaf and bloom or whole roots are best. Most plants begin to lose potency when they are crushed, ground, or powdered. Always ask what part of the plant is included, especially if you are looking at ground and powdered herbs. If you are not sure or the store is not sure, then pass.

If the herb is not in stock, ask if it can be ordered. Many good herb stores do not stock some of the herbs that are used in Native American root doctoring. They cater more to the top-selling herbs used in Western herbalism. Some of the plants that I recommend are not sold commercially, and you must find them in the wild.

If you buy bulk herbs from a store where you or a clerk measure the herb from a bulk jar into another container, be very observant of the sanitary conditions. There should be 1 scoop for each bulk herb, not 1 community scoop. Herbs should be in sealed jars that are opened for use and then resealed immediately. The herbs should be scooped out of the jar and into a paper or plastic bag for weighing. Do not put the herb directly on the scale.

This all may seem like common sense, but let me tell you my horror story. Whenever I do a workshop or class in a strange city, I like to check out the local herb stores for the availability of the things I talk about in class and to look out for things like this. The shop I visited does a brisk business in dried bulk herbs, and one clerk was dedicated to measuring and pricing the herbs for the customer. This looked good so far. I asked the clerk for 1 ounce each of 2 different herbs. The

clerk scooped out the first herb and placed it in a scoop-like metal attachment on the scale, instead of in a bag. He explained that their policy was not to charge people for the bag weight, and once weighed he then placed it in a paper bag. I was alert as he went for the second herb. When he started to dump it into the same metal scoop on the scale, I told him that these herbs really should not be mixed and asked if he would wipe out the scoop between uses. So, he politely took off his wool knit cap and wiped out the scoop with it. Yuck! Needless to say, I didn't buy any herbs there and made quite a fuss before I left.

Making Medicines

While I never recommend that you diagnose or prescribe herbs for yourself, I do think that after a course of action has been agreed on by you and your practitioner, you should be involved in making your medicine. It gives you a better understanding of the essence of the herb when you pick it, or at least feel and smell the dried herb as you make a tea or tincture. By knowing what the plant looked like or smelled like or how it grew, you develop a relationship with the plant and its healing powers. When I make medicines, I try to have a quiet environment and take the time to talk to the herb either out loud or in my mind. You should explain to it that it is needed for medicine and why you are using it. Thank it for giving its life so that you can make this medicine. I recommend that a person picture the living plant in their mind while they are taking the herb and sometimes visit a living plant in the woods or a garden. I have even potted herbs to bring them inside for invalids or into hospitals or nursing homes. In this book I may talk about administering medicines in forms that may not be familiar to you or recommend a different way to prepare the herb. In this section I'll give examples of how to make basic teas, tinctures, liniments, oils, lotions, and salves and also how to use smoke and steam to deliver medicines. When reading about a specific herb, pay close attention to what form is recommended for what problems. Sometimes a tea is better than a tincture, and sometimes a cold tea is better than a hot tea. If no specific directions are given, then the choice of tea or tincture is usually one of convenience. A tincture is often preferred when you are on the go, and a tea is nice when you are home.

Utensils
- pans for cooking or mixing;
- spoons for stirring;
- strainer and filters;
- funnel for transferring liquids from pans/bowls to bottles;
- knives, mortar and pestle, or utility scissors and coffee grinder;
- fresh water; never use distilled water to make teas. Use tap water or bottled spring water.
- labels that stick well to the containers, marking pen, and clear packing tape.

Sterilize everything before you use it to avoid contamination of the medicines. To do this, boil enough water to cover the utensils, and

place them in the boiling water for about 10 minutes. Do not boil rubber stoppers or jar lids that have rubber seals. Do not use utensils for more than one herb at a time unless you are making a specific mixture. It is best not to use plastics, cast-iron or aluminum cookware, or aluminum utensils when making herbal preparations. These can leave a bad taste in the medicine or can react with them. For cooking, mixing, boiling, or baking, a stainless steel, granite, or glass container is best.

To strain a tea or tincture, a commercial wire basket-type strainer usually has holes that are too big to filter out the herb particles. I usually line this strainer with a coffee filter, lint-free white cloth, cheese cloth, or white paper towel. Whatever you use as a filter, be sure there are no dyes, perfumes, bleach, or detergent residues. New cloth almost always has been treated with chemicals for sizing. Be sure to wash them thoroughly and then rinse 2 or 3 times in hot water until the rinse water shows no sign of detergent residue. Dry the cloth without fabric softener or dryer sheets, and store it for use on herbs only.

To strain an oil, a coffee filter or paper towel won't work. You need the looser weave found in most cotton, linen, or cheese cloth that will allow the oil through. Also, at the bottom of the batch, a great deal of oil, tea, or tincture remains in the herb. This should be squeezed out. The strongest part of the medicine is often in those last few ounces. The liquid should be strained into a large container that will hold all of it, and then stirred together before putting it into smaller containers.

All medicines should be stored in sterilized glass containers with airtight lids. The best thing that I have found is common canning jars. They are widely available and come in sizes ranging from 4 ounces to 1 gallon but are most common in pint and quart sizes. Wide-mouth jars in half-pint sizes are best for lotions and salves. Larger jars from quarts to gallons are great for storing dried herbs and dehydrated roots. Follow the manufacturer's directions for sterilizing the jars with boiling water and for sealing them properly.

Tinctures can be stored long term in glass jars also, but most of the dosage information is given in drops and eye dropper measurements. Keep a supply of eye dropper bottles on hand, and fill them only when needed. These should also be sterilized according to the manufacturer's directions.

Teas must be refrigerated and even then will only last 2 to 4 weeks. I recommend that you store them in several smaller bottles rather than 1 large container. Break the seal on only 1 jar at a time; the rest will stay fresher longer. To reheat the tea, use a stainless steel, granite, or glass pan to bring the tea up to drinking temperature. I do not recommend

using microwave ovens for reheating teas. It may have an adverse effect on the medicinal properties of the herb.

All final containers should be clearly labeled with the contents, date made, and usage or dosage information. Once the label is filled out, cover it with a clear waterproof tape. Even if the label has an adhesive backing, it is best to cover it with clear packing tape to prevent the writing from being faded by moisture. In 6 months you will not remember what is in the blue jar in the back of the refrigerator.

Making teas

In this text I use the word tea to mean anything that is made using herbs added to boiled water. Sometimes you drink it by the cup or by 1-ounce doses; sometimes you don't drink it at all. You may be directed to use it as a wet compress, a foot bath, a hair rinse, or a bath additive. Pay specific attention to the text on how you are directed to use it. No matter how it is used, the directions will tell you to make a tea. Other words like "decoction" and "infusion" seem too confusing to me.

Here's how to make a tea. Most of the directions included in the individual herb sections are for making 2 quarts of tea. This may seem like a lot of tea, but if you are sick, it is easier to make it once and store it for use over a few days.

> Bring 2 quarts of water to a rolling boil in a stainless steel or granite pan.
> Remove the boiled water from the heat, and add the herb immediately. Stir it enough to moisten all the herb.
> Cover with a tight lid.
> Allow the tea to steep for 30 to 45 minutes.
> Strain the herb through a medium to fine filter.
> Bottle the tea in an airtight glass container, and allow it to cool. Refrigerate the tea until needed.
> Put the used herbs outside under a tree or bush.

How much herb? As a general rule I use 4 tablespoons of fresh leaf and flower herbs to 2 quarts of boiled water. If the herb is dried, I decrease the amount by half to 2 tablespoons. If the herb is dried and powdered, you can reduce the amount to about 1 tablespoon. For roots, I estimate how much of the root is needed to get about 2 tablespoons of powdered root. Herbal tea bags can be used, and some places sell the empty bags that you fill yourself.

When I was learning to make teas from my elders, they never used exact measurements. Everything was measured by the palmful or handful of herb. If your hand or palm was a little bigger or a little smaller, you probably needed a little more or a little less medicine. I still measure this way, because fresh herbs and flowers are tough to contain in a tablespoon. So, however you measure it, I use about a small handful of herb that looks like 3 tablespoons to 2 quarts of water.

Roots and barks are also used to make teas. Barks are either used fresh or dried. Check the specific herb directions to see what part of the bark is used. In many cases it is the inner bark which needs to be shredded off of the outer bark before using. The original size of the bark from the tree is given in inch measurements. For example, the original bark is taken in a 4 x 4 inch sheet. Then the inner bark is taken off and used to make the tea. In the case of Sassafras, the bark from the root is the only bark that is used.

Check the specific directions for a root to determine if the root needs to be powdered or if breaking it or chopping it is sufficient. Roots are best when stored whole and should be dried or dehydrated before storing them. They begin to lose their medicinal content when they are chopped, ground, or powdered. Dried and dehydrated roots can be very hard to powder. I recommend using a large mortar and pestle to do your grinding. Grinding roots in a blender has ruined many blenders. Make sure that yours has a heavy-duty motor before trying to grind roots. A better choice is a small grinder made for coffee beans, since they are designed to powder the hard beans.

Disposal of herbs

Never throw herbs or medicines in the trash, on a compost heap, or down a garbage disposal. As a measure of respect for the plants and the lives that were given to make this medicine, all unused portions of the plant, herbs that are strained off of tinctures, teas, and oils, any leftover medicines, tea bags, and paper strainers should be returned to the earth in a respectful ceremony. Nothing formal is required, but you should have a special place like under a tree or in a garden where the medicine will not be stepped on or over. As you return the herbs to the earth, thank them for their help and thank the Creator for giving us the healing herbs and for those who have shared their knowledge of these medicines with us.

Alcohol

There are 2 kinds of alcohol that are used in making medicines: isopropyl alcohol and pure grain alcohol.

First is isopropyl or rubbing alcohol. This type is used to make liniments that are applied to the skin. Isopropyl alcohol is never used internally. It can be purchased at most grocery stores and all drugstores.

The second type is grain alcohol. This is the drinking kind found in liquor stores. Grain alcohol is used to make tinctures which are taken orally, usually in 3- to 5-drop doses. The best type is a pure grain alcohol which is sold under a variety of brand names across the country. It can be hard to find, but it is worth a little effort. Pure grain alcohol can usually be found at larger liquor stores. If you don't see it on the shelf, ask for it to be ordered for you. Other high-proof liquors can be used, but they will have other flavors and additives, and the proof (percentage of alcohol) is not as high as it is in pure grain alcohol. A higher-proof rum (151) or vodka would be my next choice. The closer to clear in color and more tasteless it is, the better suited for tinctures. Some herbals recommend brandy, but to me the flavor of brandy masks the herbal taste, and it usually has a lower alcohol content. The proof or alcohol content is what breaks down the plant and lets the medicine leach into the alcohol.

Making tinctures

Grain alcohol is very flammable. Keep it far away from flames, heaters, and stoves, and do not allow anyone to smoke while you are making or pouring tinctures. Always store grain alcohol and the finished tinctures in a cool, dark place.

Tinctures made from my recipes are taken in average doses of 3 to 5 drops taken four to five times a day. Some herbal books will give recipes and recommend that you take anywhere from 15 to 40 drops. If you are taking their medicine, then follow their instructions. This is also true for prepared commercial tinctures. Follow the instructions on the label. However, if you find that the symptoms are getting worse, you should cut back or discontinue use. Many herbs can cause the same symptoms that they cure. Usually the cure comes with smaller doses instead of larger. In the case of herbs, less is better.

To take a tincture, place the drops under your tongue. This gets the medicine into the bloodstream much faster than any other method. If you swallow it, the medicine needs to travel through the digestive system and won't be as effective or work as quickly.

To make a tincture, fill a glass jar half full with loosely packed fresh herb, whole or broken roots, or shredded bark. If you are using powdered roots, barks, or herb, or dried herbs, then only fill the container one-quarter full. The amount depends on the size of the jar, but for a quart jar it takes about 1 ounce of dried herb. Since you take small doses of tinctures, I recommend starting with pint jars or smaller. For those that I use frequently or for long-term use or recurring problems, I will make 1 quart of tincture.

Fill the container with grain alcohol, and leave about one-half inch at the top of the jar for shaking room. Place an airtight lid on the jar securely, and shake it very well for at least 1 minute to moisten all of the herb. For powdered herbs, check the bottom and sides for stubborn clumps, and be sure that all of the herb is mixed. The tincture needs to be shaken two times a day for 7 days. This allows the herb time to release its medicine into the alcohol. At the end of 7 days, the liquid can be strained off and bottled for storage. Do not keep the herb in the tincture for more than 10 days. After this, the medicine will start to degrade and can react with the herb like fermentation. See the previous sections for proper disposal of herbs and bottling suggestions. The tincture can be stored in a cool, dark place, away from any heat sources for 5 years or more if kept sealed.

Cutting tinctures

When using herbs remember that less is better. When you make a tincture according to the directions in the previous section, the resulting alcohol-based tincture is called the "mother tincture" or first generation tincture. Sometimes a plant is so strong that the mother tincture needs to be cut back to minute doses. In the full-strength form, it may cause or aggravate the symptoms for which you are taking it. Sometimes I will recommend that a tincture be cut back one time, five times, or ten times.

Even when you need to cut the tincture, first make the mother tincture according to the directions. Then the mother tincture is mixed with an equal amount of either water or pure grain alcohol. This produces a tincture cut one time from the mother tincture. For each additional cut, this process is repeated by adding an equal part of either water or alcohol to the last cut. Shake the mixture very well between each cut.

Start with a very small amount of mother tincture, because for every cut the amount of final liquid doubles. If you start with 1 ounce of the mother tincture, here is how the tincture grows:

1 cut yields 2 ounces
2 cuts yield 4 ounces
3 cuts yield 8 ounces
4 cuts yield 16 ounces
5 cuts yield 32 ounces.

By the time that you reach 10 cuts you will have 8 gallons of tincture from 1 ounce of mother tincture.

Water is good to use for cutting a tincture one time but, for more diluted cutting you should use enough pure grain alcohol to retain at least 50% alcohol in the tincture for a preservative. The easiest way to do this is to use water for the first cut and alcohol for the second cut and continue alternating them. Before you make the last cut, check to make sure that the percentage of alcohol will be what you need.

Making liniments

Liniments are only used externally. Herbs are soaked in either isopropyl alcohol or Witch Hazel to make a liniment. Use about 1 ounce of herb for 1 quart of liniment. Place the herb in a jar and fill with alcohol or Witch Hazel. It needs to be shaken twice a day for 7 days and then strained and bottled for use. Roots and barks can generally be used three times for a liniment before the herb needs to be changed. Strain the liquid after 7 days, and then refill the jar up to three times. Each time you refill it, you must allow it to soak for 7 days and shake it two times a day. Leaves and flowers used for liniments should only be used one time. After straining for the final time, the herb should be put outside under a tree.

Liniments are used by liberally splashing them on the skin and then rubbing them in until they are absorbed and the alcohol evaporates. A liniment can also be applied with a cloth and used like a compress. For liniments being used for sore muscles and joint pain, heat can help relieve the pain. Do not use a heating pad. Instead, use a cloth soaked in hot water as a compress over the liniment. Alternate applying the liniment and then covering the area with a very warm wet cloth for 2 to 3 minutes.

For some people, isopropyl alcohol can dry out the skin. If this is a problem then try switching to Witch Hazel instead of isopropyl alcohol. It can be used interchangeably with alcohol and is sometimes preferred. I use Witch Hazel for liniments that are being used near sensitive areas. For example, the best relief for hemorrhoids is a Witch Hazel liniment made with 2 tablespoons of powdered Goldenseal to 1 pint of Witch Hazel. Soak a small cloth, white paper towel, or white toilet paper with the liniment, and stick it where the hemorrhoids are

itching, burning, or bleeding. Do not use alcohol for this liniment. It would cause a burning sensation that is quite unpleasant. Leave the compress there for 3 to 5 minutes for quick relief. For severe problems and bleeding hemorrhoids, leave the compress on overnight.

I also recommend this mixture for travelers. Soak several small swatches of white cloth or white paper towels, and put them in a plastic bag to carry in your purse or briefcase for emergencies. They are good for small cuts, hemorrhoids, acne, rashes, and anytime you need to clean up a wound.

Quick starting a tincture or liniment

Sometimes you just can't wait 7 days for your tincture or liniment to be ready. Someone is sick or sore now and needs your help. Here is a method to make your liniment or tincture be close enough to full strength to start taking it within a few hours. The 7-day method is safer from a fire hazard point of view, and you are less likely to break a jar and lose your batch of medicine. I only recommend this for emergency situations. Always use canning jars for this method, since they are designed to better withstand temperature changes. Remember to keep both kinds of alcohol away from flames and heat sources such as the stove. They are very flammable.

The idea behind quick starting is to apply heat to the tincture or liniment by using hot water. You must start the tincture or liniment in the canning jar in the same measures as the 7-day method. Tighten the jar lid and shake it very well for 1 to 2 minutes to make sure that all of the herbs are moist and mixed. Then loosen the lid halfway to allow any pressure to escape as you work.

Place the jar in the sink or a smaller pan or bowl, and run warm water around the jar. Start with enough warm tap water to bring the water level about halfway up the outside of the jar, but do not make the jar float. While the jar soaks and starts to warm, start a different pan of water boiling on the stove. Never place the jar in the pan on the stove. You will add boiling water to the sink in small amounts to gradually bring up the temperature. After you have reached the hottest temperature that you can using tap water, then begin adding the boiling water in 1-cup increments about every 3 to 5 minutes. If you bring up the temperature too quickly, the jar will crack and the medicine will have to be discarded. Also, if you let the jar cool too quickly or place it in a draft or in front of a fan, it can break. You should continue to add hot water to the bowl, but pour some of the cooler water off each time so the water level stays consistent. You should continue the warming-up stage for at least 1 hour. Do not remove the glass jar from

the hot water. When the hour is up, let it remain in the hot water and let it cool off gradually. In 2 to 3 hours the jar should be cool enough to handle, but test it first. Tighten the lid and shake the mixture. If you have the time, allow the jar to sit in the water overnight; it will be ready to strain and use in the morning. If the situation is an emergency, you can strain off enough for a night's dose, and let the rest cool naturally until morning.

Making oils for internal use

Oils that are being used internally are never cooked or heated but instead are made by a cold press method. Fill a jar half full with the dried or fresh herb and fill the jar with extra-virgin olive oil. This herb and oil mixture is kept in a cool, dark place and allowed to soak for 30 days.

After 30 days the oil is strained off and the herb is pressed using a lard press or can be wrung out using cheese cloth or loose weave white cloth. If you choose to wring it out by hand you must exert as much pressure as possible in the wringing to extract as much oil as possible. The last drops of the oil contain a greater concentration of medicine and should be mixed well with the rest of the batch.

Cold pressed oils should be stored in the refrigerator and allowed to warm to room temperature for use. If you want it slightly warmer, as for ear drops, then warm it by running warm water over the container. Do not heat it on the stove or in a microwave.

Making oils, lotions, and salves for external use

First, you must decide how thick you want the final product to be. The 3 basic oils that I use are extra-virgin olive oil, coconut oil, and beeswax. Olive oil will not thicken at all at room temperature and just slightly if you refrigerate it. Coconut oil is a solid up to about 75°F and can withstand slightly warmer temperatures without spoiling. Coconut oil can be melted by placing a jar of it into very warm tap water. It will stay melted until the jar of finished product is refrigerated or left in a cool place overnight. Beeswax is very hard and needs to be heated on the stove in a double boiler before it will melt. It will begin to harden again as soon as the air hits it. I only use beeswax to thicken or harden the final product and always start the process with either olive oil or coconut oil.

If you want a thin lotion, then begin with olive oil and later thicken it with coconut oil. The amount of coconut oil will determine how thick the lotion is. The more you add, the closer it will get to a cream

or salve. For a thick cream or lip balm, start the process with coconut oil and then thicken it with beeswax. Most of the recipes that I use for classes and workshops will make about 2 gallons of salve or 30 to 32 half-pint jars. This is enough for everyone to be able to take some home. I recommend that you start with much less for home use.

For your first batch, start with about 1 pint of oil and 1 to 2 handfuls of herb. Choose an oven-safe pan made of stainless steel, granite, or glass. It should be small enough so that the oil will completely cover the herbs. Place the herbs in the pan, and cover them with the oil that you choose, either extra-virgin olive oil or coconut oil. Do not add the thickening oil until the herbs have been strained from the first oil. If the herbs are not covered, then add a little more oil. Stir this together, making sure that all of the herbs are moist and under the oil. Place the covered pan into a 200°F oven for about 4 hours, stirring every 30 minutes. When finished, the herbs will be crunchy. If they are not crunchy at 4 hours continue cooking and check them every 30 minutes. Large batches can take 6 to 8 hours to cook; smaller batches should be done in 4 to 5 hours. Remove the oil from the oven, and allow it to cool. When the oil is slightly warm but not hot, you can begin to strain it. Place the oil and herbs into a large straining cloth, 1 spoonful at a time, and allow enough room so you can wring out all remaining oil. Place the strained herb in one container, and let the oil strain into a large bowl. Continue this process until all the herb and oil is separated. After the first straining, look closely at the oil and see if there are any herbs left that did not strain. Sometime you may want to leave them for creams and salves, but for ear oils you should make sure that the oil is as clear as possible. You may want to strain this twice. At this point, an oil is finished and can be bottled in your choice of containers. Vitamin E oil or vitamin C oil can be added as a preservative. Otherwise, the mixtures will need to be refrigerated for long-term storage.

If you want a thicker lotion or salve, you will need to add beeswax to thicken the oil. The more you add, the harder the salve will get. Getting the consistency just right takes practice, and you should keep track of the amounts and types of oils that you experiment with. Remember though, if a salve is too thin, just melt it a little and add more beeswax. If it is too thick, you can melt it a little and add some olive oil. This part really depends on your preference.

To mix beeswax with any combination of oils, you will need an electric mixer and enough cold water or ice water to partially submerge your mixing bowl. The beeswax should be kept on a low heat until you are directed to pour it into the mix. Place the herbal oil into a large

mixing bowl, and begin beating it with the mixer on a medium-high speed. This will further cool the oil and allow it to start setting. If you use a higher speed after it starts to set up, it will add fluff to the final cream. If the oil is still very warm, set the mixing bowl in enough cold water or ice water to come about halfway up the outside of the mixing bowl. Add ice as needed, but do not splash water into the mix. It may take 15 to 20 minutes for this to start to harden. Once the original oil begins to get cool, the beeswax can be added. Take the bowl out of the ice water. The ice will harden the beeswax too quickly and cause it to lump. Slowly pour the beeswax, one-half cup at time, over the beaters of the mixer while it is running. Make sure it is well mixed. Beat the mixture for several minutes and test the consistency before adding more. Be sure to scrape the sides of the bowl and blend this in before testing. If the mixture is not getting hard quickly enough, you can set the bowl back into the ice water again and continue beating it until you get the consistency that you want. Store thicker salves in half-pint or smaller wide-mouthed jars. Check the containers before you fill them to be sure that you can reach the bottom and all parts of the jar. Fill and seal the jars, and be sure to label them with the contents and the date they were made.

Transdermals—absorbing medicine through the skin

The skin is the largest organ of the body, and our bloodstream is directly connected to it. We absorb many medicines through our skin in obvious ways, like using a liniment or lotion that is rubbed on the skin and then absorbed. Some plants are applied directly to the skin and absorbed. Bloodroot is one example. It is rarely used as a tea or tincture for women's problems. Instead, the fresh root is broken open and used like a red marking pen to paint the medicine on the wrists and neck to help balance hormones.

Capsules and pills

I seldom recommend that you use commercially produced pills or capsules unless all other options for finding fresh or dried herbs are exhausted. But for some remedies I do suggest that you make your own capsules. A case in point is a Boneset remedy for osteoporosis. Boneset makes a very bitter tea, but the tea or capsules are preferred over the tincture for this application.

Empty gel capsules are sold at most health food stores or herb stores and can easily be filled at home with dried and powdered herb. The

capsules come in a variety of sizes that can be chosen based on the dosage requirements and your ability to swallow them.

Before the technology of capsules and pre-made pills was created the Native people made their own pills. The traditional method is to mix the dried, powdered herb with an equal part of flour. Add enough water to make a thick dough. Shape the dough into pill sizes that you prefer, and allow them to air dry. Make sure the pills are thoroughly dried before storing them. These pills are usually made in batches large enough to last 2 to 4 weeks and are not for long term storage.

Other medicine-delivery forms—smoke, steam, and spiritual fumigants

The antismoking campaign against cigarettes has made it very difficult to convince people that smoking some things can improve your health. In fact, smoking dried Mullein leaf can clear up your lungs and improve breathing problems, including asthma and emphysema. Western Sage leaf is burned and the smoke is inhaled to clear out sinus infections. In both cases at first, you will cough more than usual as nasty things come out of your lungs and sinuses, but they will improve and breathing will be much easier. Throughout my classes I mention herbs that can be added to smoking blends as a replacement for cigarettes and some to help you reduce your dependence on nicotine and the hundreds of chemicals that are packed into some cigarette brands.

Other plants are used as a smudge. To smudge or burn a smudge is to light a bundle of an herb with a match and then blow out the flame to allow the herb to smolder. The smoke is inhaled through the nose and into the lungs to provide relief. For example, the root of False Solomon's Seal is lit and allowed to burn until it will retain enough heat to smolder. Then the smoke is inhaled for headaches and nervous tension.

Steam baths are used by cultures around the world. The Scandinavians gave us the word sauna, and Native Americans bring us the sweat lodge. In the latter case, steam is created by heating rocks and then pouring water over them to create the steam. In our culture, the sweat lodge can be used for spiritual reasons and in other cases for medicinal reasons. In a medicine sweat lodge, specific herbs are made into a tea which is poured over the rocks to create a medicinal steam, or an herb is placed directly on the rocks and allowed to smolder. You can get the same medicines from the herb steam by using a sauna or steam bath. If you don't have access to these, I recommend using your

bathroom shower. If you don't get into the shower, you can let the water get much hotter and produce more steam. This works well when herbs are burned and the smoke is mixed with the steam in an enclosed room. For herbs that are boiled or made into a tea, you can use a vaporizer or just boil the tea and inhale the steam as it boils. Be very careful trying this. Steam can cause third-degree burns.

Spiritual fumigants are sometimes burned or sometimes boiled to release an aroma that changes the spiritual feeling of a person or room. In the case of Wild Bergamot, it is boiled to relieve tension or dispel anger and violence in a room or house.

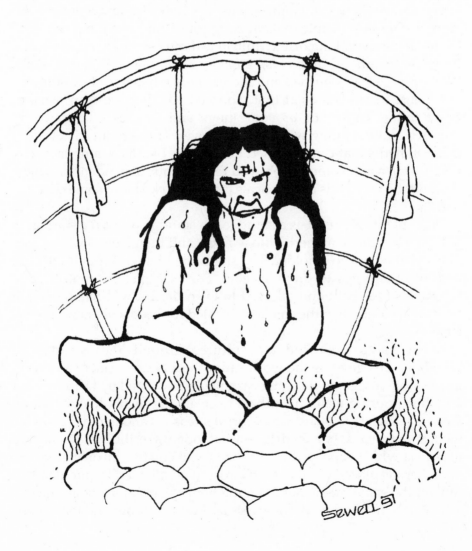

The Plants
Sweet Leaf/Wild Bergamot

Wild Bergamot, *Monarda fistulosa*
Bee Balm, Oswego Tea, *Monarda didyma*

Sweet Leaf is one of the Muskogee Seven Sacred Medicines. As with the other sacred plants that we will discuss, it seems to be almost a panacea or a cure-all because it will fix so many problems. The Muskogee people called Wild Bergamot "Sweet Leaf" or "Indian Perfume." In this text Sweet Leaf is used to refer to the purple-flowered Wild Bergamot. A related species, *Monarda didyma*, known as Bee Balm or Oswego Tea, has a red or pink bloom and can be used interchangeably, but it is not the preferred plant.

Two types of *Monarda* are recognized by the Western scientific community. In Muskogee herbalism, we recognize 45 different types. Western science considers these other types to just be anomalies within their recognized types. But observing these plants and gathering their seeds, I have found that when the seeds of a unique strain are planted, they produce offspring with the same unusual characteristics. Now, I don't claim to know much about Western scientific methods, but I think of these as unique plants. In some cases they are used for specific medicinal needs and are gathered, stored, and used differently.

For this text we will stick with the Western definitions of *Monarda* in all cases but one. Some Sweet Leaf plants that are found look like they have a mold growing on the leaves. On closer inspection this is not mold but a grayish spotted pattern. The spots look like lungs; that is their signature that they are the preferred variety for lung problems and are the type to seek out for tuberculosis and bird sickness mentioned below.

Doctrine of signatures

Sweet Leaf is an excellent example of the doctrine of signatures. The Latin name of Wild Bergamot is *Monarda fistulosa*. *Fistulosa* refers to the little tubes or fistulas in the flower. The doctrine of signatures tells us that this plant has to do with diseases of the tubes, but here it is more specific to the ear. Another signature of the plant is the color purple. Things that are colored purple have to do with nerves, passion, the heart, or human spirit. In this case it tells us that it is a nerve tonic. The appearance of the purple pom-pom flower is like that of a

person with their hair standing on end, which is another good indication that the flowers are good for frayed nerves. The leaves and stalk have signatures that they are good for nerves too. Their serrated leaf edges show that they are good for cutting pain or frayed nerves. The leaves grow on the stalk in pairs with 2 leaves right across from each other (which looks like a nerve sheath). This makes it known as a nervine and a member of the mint family.

Essence of the plant

Sweet Leaf is the remedy to draw out the fire. Burns and heat from fevers or infections are its speciality. It seems to open the pores of internal organs, as well as the skin, to remove heat or draw out the fire.

Lung infection, tuberculosis, bird sickness

This is the one area where you should seek out an unusual type of Sweet Leaf that is often found in the wild, but is not available as a separate product at herb stores. You will need to find this one on your own. As mentioned above, this variety will have grayish spots on the leaves that look like mold at first. On closer inspection you will see that it is a natural leaf pattern. The grayish spots resemble lungs and are its signature that you have found the correct plant.

This variety of Sweet Leaf is used as a tea or tincture in the treatment of lung infections, tuberculosis, and bird sickness, which is a lung infection caused from living near roosting birds. Bird sickness can cause a false positive test result for tuberculosis.

Skin rashes, dermatitis, stings, or bites

A lot of people get into plants that they think are poisonous. It could be St. John's Wort, or it could be Wild Cucumber. Even Ginger and Catbrier can make some people break out like poison ivy does. Sweet Leaf is used as an anti-irritant to any of these plants.

Sweet Leaf or Wild Bergamot is an astringent. It is made into a strong tea and used to clean wounds and is good for burns, poison ivy, and bee stings.

The leaves and blooms can be chewed up and the saliva and herb mixture applied to an area of bites, stings, or rashes where you need a stronger drawing agent. Something in the saliva activates the healing properties of Sweet Leaf. If you crushed it up and mixed it with water and put it on a bee sting, it wouldn't have the same drawing effect. The common name, Bee Balm, was given because it was used to draw out stingers. Sweet Leaf also works well for pulling out splinters and slivers in the skin.

40

Sweet Leaf is particularly effective against whatever poisonous plant it is growing near. When in the woods, if there is poison ivy, an antidote grows within an arm's reach. With Wild Bergamot, you touch the flower and walk in a circle and somewhere within the circle is poison ivy, poison oak, or poison sumac. The one that grows closest to the Wild Bergamot is the one that it is specifically good at healing. I believe they have exchanged certain properties underground that make the Wild Bergamot more specific to that plant. If applied promptly after exposure to one of these poisonous plants, Sweet Leaf may prevent the rash from ever appearing.

Nerves—depression, anxiety, insomnia

Sweet Leaf is used as a nervine in either a tea or tincture form for depression or anxiety. As the paired leaf pattern shows, it is good for balancing the nerves, so it is effective for nervous problems of either type, bringing you up out of depression or down from anxiety attacks. It actually repairs nerve damage to relieve even chronic anxiety or chronic depression. In a tea form, drink 3 to 4 cups per day. When you are having an episode, drink 1 cup immediately. In tincture form take 3 to 5 drops under the tongue, five times per day. For an episode, take 5 drops immediately and continue taking 5 drops every 15 minutes until the episode subsides.

To use Sweet Leaf for insomnia, drink a cup of tea about half an hour before bedtime or take 10 drops of the tincture under the tongue as you are going to bed. For people who go to sleep and then wake up during the night, keep a bottle of tincture on the night stand and take some when you wake up. Also, the leaf and bloom can be crushed up and put into a sachet or a small stuffed toy for children. When you have trouble sleeping, gently squeeze the sachet under the nose and inhale deeply a few times. It will ease you to sleep. This was used by native people who were on the run from the cavalry or enemies. When women with small children were forced to run and hide for their lives, it was understood that a crying child must be silenced so the rest of the group would not be discovered. Often this meant that the mother and child must go off by themselves until the child was quiet and they could safely return to the group. It was important that mothers had a supply of Sweet Leaf with the child to keep them calm. Small stuffed toys were often attached to the cradle board.

Sometimes the entire household is in an uproar, excited anticipation, or is severely depressed due to a death or tragedy. Sweet Leaf makes an excellent household remedy because it is mild enough for infants, elderly, and invalids. It can be used to treat everyone by bringing a

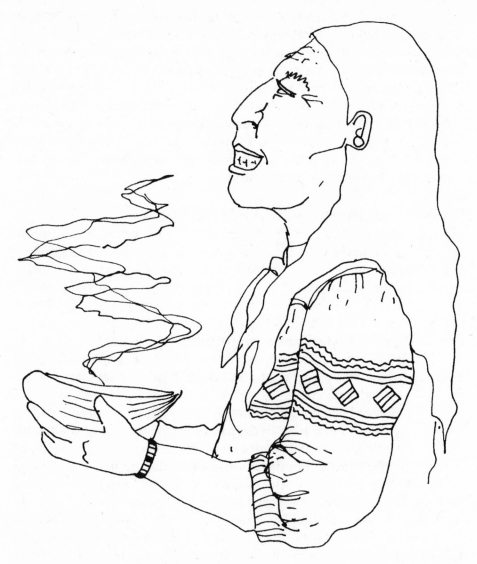

pan of water to a boil, then turning the heat down to a low simmer. Add a handful of Sweet Leaf to the water and allow it to simmer, and the steam will carry the calming fumes through the house. It can also be used like potpourri or mixed with water over a votive candle.

Nerves—hyperactivity, calming anger and violence

A tea can also be used for hyperactivity in both adults and children. When there is anger or nervous excitement in the house, Sweet Leaf makes a great addition to potpourri or can be simmered in a pot on the stove. This is an excellent remedy for those rainy days when the kids are home and full of energy or bickering out of boredom.

The leaf and bloom are crushed between the fingers, and the aroma is inhaled for its calming effect and to remove negative thoughts. (I often use this when forced to entertain unpleasant company or in stressful situations.)

For violence and anger in the house, Sweet Leaf is used differently depending on when it is being used. If you feel the anger building or stress mounting, then it is time to put a pan of Sweet Leaf on the stove. Sweet Leaf oil can also be rubbed on a cool light bulb. Then switch on the bulb. These methods are best used before the anger erupts.

After an episode of violence, anger, or fighting, it is better to burn the leaves and blooms of Sweet leaf as a spiritual fumigant.

When you enter a room where there has been an argument, violence, or a fight, people often say that they can feel it in the air or feel the bad vibes or sense the bad feelings hanging in the air. The Muskogee people believe that the anger is still clinging to the walls, furniture, and people. Sweet Leaf would be burned to release the anger and send it away.

Nerves—corpse sickness, death depression

Sweet Leaf is also crushed and inhaled for corpse sickness. This condition includes all types of depression caused from being around dead things or smelling putrid animal or plant flesh, even from working in your compost, preparing meat, or cleaning those things that look like science projects out of the refrigerator. Take a bloom of Bergamot, crush it between the fingers, and smell it very deeply into your sinuses. The vapors will help sanitize the inside of your sinuses and gets rid of the corpse smell. Bergamot may also be inhaled during funerals to ward off the depression associated with death. I have personally advised a mortician, a compost gardener, and a butcher to use this treatment to combat their depression, and each has reported very good results. This plant should be of special interest since depression is the number-one mental illness in the U.S. today.

Nerves—severed or damaged nerves

For nerves that are damaged from accidents, treatment should be started as soon as possible. The sooner treatment is started, the more successful it is likely to be. A tea or tincture can be used and will need to be used for a long period of time. Nerve regeneration is a slow process, but not impossible. Sweet Leaf has shown success even when the nerves were completely severed. This is something that must be treated by a trained practitioner. Do not attempt to treat yourself.

Skin—burns, sunburn to third-degree burns

Another important use of Sweet Leaf is for burns. It is effective for any type of burn from sunburn to third-degree burns. For severe burns, second- or third-degree burns, or burns over a large area of the body, you should always seek professional help.

Sweet Leaf has an antiseptic effect which cleanses the wound and draws the fire out of the body. This is the key to faster relief of pain from burns and faster healing of the wound. The worst things you can

do for severe burns are to use cold water or oil-based products. Cold water will drive the burn to deeper tissue and worsen the injury, and oil-based products seal the fire inside, causing the skin to fry. You want to draw the heat out of the body so that the healing can begin.

To use Sweet Leaf for sunburn, make a compress using a white cloth soaked in tea that is room temperature or slightly cooler . Leave the compress on the area for 2 to 3 minutes, or less if the compress becomes warm. Remove the compress and allow the area to air dry. You can repeat this process as often as needed to reduce pain. Continue to use the compress for 1 to 4 days (depending on the severity of the sunburn) to decrease the risk of blistering and peeling.

For first- to third-degree burns: If the burn was caused by contact with a foreign matter that has left debris on the burn, first rinse the area with sterile room temperature water to remove any loose foreign matter. The blooms and leaves of Sweet Leaf are chewed and the saliva and herb mixture is applied to the area for about 5 minutes. Then the area is rinsed with sterile room temperature water to remove the herb and any foreign matter it has drawn out. Wait about 15 minutes, then reapply freshly chewed herb and repeat the process. Since Sweet Leaf is a drawing agent and astringent, it will help clean out the burn area as well as drawing out the fire and relieving the pain.

WARNING: The chewed leaf and bloom should not be left on the burn for more than 3 to 5 minutes. Sweet Leaf acts as a burning agent and can cause a burn or scar to become worse if left on any longer.

At first, the pain will seem to get worse as the Sweet Leaf creates its own heat to drive the fire out of you. When the burn is severe or covers a large area, Sweet Leaf can also cause a fever or sweating as it draws out the fire.

One case history that I will share involved a woman who opened the radiator cap on her car when the engine was too hot and the radiator fluid sprayed all over her face, chest, and arms. She was taken to the local doctor where they cleaned the wounds, dressed them, gave her creams and pain pills, and sent her home. She was in severe pain when her family asked me to help. Because the injured area was so large, I asked her sisters to help us chew the Sweet Leaf to apply to her burns. It helped them as a sedative to calm their anxiety over their sister's injuries, and it was calming to the injured woman as well. I usually don't recommend using other people's saliva to treat your wounds but, as sisters, their body chemistry was very similar. Like organ donors, I figured the closest matches would be from these

blood relatives, especially sisters. When the first application of Sweet Leaf was rinsed off, there were tiny chunks of rust and green radiator fluid that were drawn out of the wounds. We used about 4 applications of Sweet Leaf that night, leaving them on for about 5 minutes each and then irrigating the areas with sterile room temperature water each time. She reported that the next day she was already starting to heal. She noticed that she did not feel the hot pain that you normally get the next day when you get a burn near heat again. Areas that were mildly burned and red had faded away, and only the more severely burned areas needed additional treatment. We kept repeating the Sweet Leaf treatments two to three times per day on any remaining areas until they were cleared completely. By continuing use, we were able to prevent the scarring that is common with severe burns.

Fevers

Sweet Leaf works on fevers in the same way it works on burns, by drawing out the fire or heat and breaking the fever. The chewed blooms and leaf are rubbed on the palms of the hands and the soles of the feet. The fever will exit from these two places.

If the fever is severe and convulsions are possible, a towel or sheet is soaked with Sweet Leaf tea and used to wrap or cover the body. Leave the cover on for 3 to 5 minutes, and then allow the body a few minutes to air dry. Resoak the cover and repeat as needed until the fever breaks. Sweet Leaf is gentle enough to be used on infants, invalids, and the elderly.

Hypothermia, frostbite

A lukewarm Sweet Leaf tea will help relight your internal fire when you are suffering from hypothermia. Drink 1 to 1½ ounces every 15 minutes until the body temperature has returned to normal.

The room temperature tea can also be used as a wash or bath for frostbite. With frostbite you are probably suffering from hypothermia also, so use the tea as above internally, and use it as a wash or bath on the outside to improve circulation to areas suffering from frostbite.

Warning: Do not use hot tea or other hot liquids in either case.

Skin—scar tissue

Sweet Leaf can also be used to remove or fade old scar tissue. In general, the newer the scar, the easier it will fade, while older scars may take longer or not fade completely. Also note that Sweet Leaf will

only work on a scar when used on consecutive days, once a day at least. If you quit, forget, or skip a day, the Sweet Leaf will stop working. Chew the bloom and leaf and apply it to the scar at least once a day until the scar fades completely or is not fading anymore.

Warning: The chewed leaf and bloom should not be left on for more than 3 to 5 minutes. Sweet Leaf acts as a burning agent and can cause a burn or scar to become worse if left on any longer.

Digestion—upper digestive tract, mouth, throat, stomach

The stems of Sweet Leaf can be used to make a mild tea for treating colic, nausea, flatulence, menstrual cramps, coughs, and sore throats. Six- to eight-inch lengths of the stalks are tied into bundles and commonly referred to as tum-tum sticks. A weak tea is brewed by placing the end of a stick into a cup of boiling water and allowing it to steep for 20 to 25 minutes.

Chewing the bloom and leaf of Sweet Leaf offers many benefits. We've talked about using the herb and saliva externally for rashes, burns, and scars. But swallowing the juices and even the act of chewing or holding the chewed herb in the mouth can help draw out poisons in the mouth and digestive tract. If the flower head is chewed and swallowed, it is good for traveler's disease, food poisoning, salmonella, and indigestion.

The chewed leaf and bloom also pulls poisons and infections out of gum and mouth sores, bites on the tongue or mouth, and bleeding gums, and treats chronic halitosis. If using it for one of these problems, it is best not to swallow the herb since this could carry the poisons through the digestive system.

Digestion—lower digestive tract, urinary tract

A stronger tea is made using about 3 tablespoons (a small handful) of dried leaf and bloom to 2 quarts of boiled water and letting it steep for 30 minutes. This tea can be taken by the cupful two to three times per day. It stores best in a sealed container in the refrigerator and can be heated as needed.

A tea or tincture of Sweet Leaf can balance the digestive system and fight off infections. It is taken for either diarrhea or constipation. It releases bile from the gall bladder and helps constipation. We use it for gall bladder colic. It is very good after a binge of eating or drinking as a hangover medicine. It is also used for fevers and infections of the urinary tract, bladder, and kidney.

The tea is also a powerful medicine against recurring yeast infections, candidiasis, vaginitis, and diverticulitis. Sweet Leaf can also be applied topically for quick relief from vaginal or rectal itching or burning. Wet a sterile pad or feminine hygiene pad with a strong tea, and cover the area for 3 to 5 minutes. Although you should not leave it on for more than 5 minutes at a time, you can repeat treatments every 10 to 15 minutes, as needed.

Blood infections, syphilis, gonorrhea

A strong tea is used to treat both bacterial and viral infections in the blood. In colonial days it was used as a treatment for syphilis and gonorrhea. These conditions should only be treated by a trained professional.

Ear infections, ringing in the ears, tinnitus, Mineir's disease

Ringing in the ears can be caused by an imbalance in the ear oils where the tiny bones, the hammer and anvil bones, connect. Sweet Leaf balances the oil content in the ear and removes the ringing. A tea or tincture can be used for this problem. Use a strong tea taking 1 cup three to four times per day. For a tincture, take 5 drops under the tongue five times per day.

The blooms of Sweet Leaf are made into a cold pressed oil that is used for ear infections. The blooms are soaked in olive oil for 30 days. (See the section on "Making oils for internal use, page 34.") Place cotton balls in the ear after using the drops to prevent drafts.

Muscles—relaxing, sore muscles

A very strong tea is made by adding a large handful of Bergamot to 1 quart of boiling water. Steep this for 30 to 35 minutes, and then strain off the herb. Add the tea to a hot bath. This bath has a calming, soothing effect on the nerves and muscles.

Warning: Be very careful not to fall asleep in the tub. Sweet leaf will relax you, and you may become drowsy. Don't stay in the tub for more than 30 minutes. If you feel tired, have someone else check on you every 15 to 20 minutes, or set an alarm clock.

Appendicitis

This remedy is given to show both the power of this plant and the range of medical knowledge held by the Native people prior to European contact. Appendicitis is a serious medical condition that should only be attended to by a professional practitioner. Sweet Leaf has been used by Native herbalists and in survival situations when regular medical care is out of reach.

Place a warm moist cloth that is saturated with a strong Sweet Leaf tea or a dropper of tincture on the appendix area. Give Sweet Leaf tea internally every 10 minutes for the next 24 hours or until the fever breaks and the temperature returns to normal.

Sweet Leaf removes the stagnation or toxins that cause the appendix to inflame. It draws out the infections and calms, relaxes the nerves and muscles, and lets any obstructions or toxins pass out of the system.

Love Medicine

Sweet Leaf is considered an Elk Medicine. Elks have to do with love, so an Elk Medicine is a love potion of sorts. Male elks will roll in a patch of Sweet Leaf to attract a mate. This is not recommended for humans, since Sweet Leaf often grows near poison ivy and poison oak.

Mixtures

Sweet Leaf and Catnip are mixed together in a tea for a relaxing sleeping aid.

Sweet Leaf, Boneset, and Solomon's Seal tinctures can be mixed in equal parts for flu symptoms. The tincture is taken 3 to 5 drops under the tongue three times a day. This should be continued for 7 days, even if the symptoms seem to go away. If flu symptoms continue for more than 7 days you should still go off the tincture for at least 4 days. Then resume for another 7 days. During the 4 days off, you can substitute other flu remedies.

Mint teas: Sweet Leaf is a mint. I recommend that most herbs in any form should not be used for more than 7 consecutive days. After this, the body starts to become immune to the healing properties, and the herbs can actually feed the disease or problem that you are trying to correct. With most remedies I advise that you take 7 days on and then switch to another remedy for at least 4 days. Sweet Leaf can be used in most recipes that call for a mint.

Cooking: Sweet Leaf is a flavorful addition to chili or soups. Use a tablespoon to 2 quarts. I always add Sweet Leaf and Boneset to my soups in the winter as a cold and flu preventative. A pinch or 2 of the ground leaves are also good seasoning for beef and deer roasts.

Smoking blends

Many people are turning to herbal smoking blends as an alternative to tobacco. Sweet Leaf can be added to these in very small amounts. Use only 1 to 2 crushed blooms per pound of smoking blend.

Smudge ball for sore throats, upper respiratory infections, as an expectorant for loosening phlegm

Create a ball or nest with 2 to 3 Mullein leaves. Put 2 to 3 Sweet Leaf blooms and 2 to 3 pinches of cedar bough needles into the nest, and squeeze it into a ball. Add sumac berries if you are coughing up

blood. Light the ball in a smudge pot or iron skillet, and put out any flame. Allow the herb to smoke. Inhale the smoke deeply. This mixture can also be smoked in a pipe. This mixture should cause coughing, as it rids the lungs of any fluids and infections. Be sure not swallow anything that you cough up. Get it out of the body.

An alternative method is to use the smudge with moist heat or steam. An easy way to do this is to sit in the bathroom with the door shut and the shower running. If you don't sit in the shower, you can let the water run as hot as possible. Burn the herbs as above, and inhale deeply, taking in the smoke and steam.

Soap

An easy way to make an herbal soap is to melt down a plain, white floating soap or glycerin soap that can be purchased at most health food stores and co-ops. We also recommend that you select an unscented soap base so you do not mask the natural therapeutic value of the herbal scents.

Mix:
2 cups Sweet Leaf
4 heaping teaspoons of finely ground Cedar/Thuja
4 rounded teaspoons of finely ground Goldenseal
Add the herbs to 42 ounces of coconut oil that has been melted. Stir thoroughly and heat in a 250°F oven for 3 to 4 hours or until the Sweet Leaf leaves are crunchy. Strain off the oil and press the herbs to remove the remaining oil.

Melt 8 to 10 bars of soap that have been grated or whittled for easier melting.

Pour the herbal oil into the melted soap, and stir thoroughly.

Add 1 to 1½ cups of melted beeswax to thicken the soap to the desired consistency.

Pour the soap into small, wide-mouth containers or soap molds, and let them harden.

This soap is used for sealing and cleaning wounds and is a strong astringent. It is good for skin rashes like eczema and psoriasis, poison ivy or oak, heat rash, sunburned skin, and acne. Used with a bath, it will calm tense muscles. It is used for chronic fatigue syndrome and for nervous stress and agitation. It is recommended for a bath before going to a funeral, because it is used for corpse sickness. It is also good for hunters to use before going into the field. It has a natural smell of the woods and does not confuse or alert the animals.

Bloodroot

Sanguinaria canadensis

Warning: Bloodroot should not be used by pregnant women and should not be used by men or women on hormone therapy or taking chemotherapy. These people should not use bloodroot in any form, including skin painting or as a tooth powder mixture.

A root tincture should be diluted ten times from the mother tincture, so you are only using a minute amount of the herb. A tincture of the fresh leaves should be cut in half or cut one time from the mother tincture. These tinctures can be toxic in large or strong doses. The tinctures can also cause tunnel vision that can last 2 to 3 days.

Bloodroot is primarily used as a women's medicine. It should only be gathered by women or two-spirited people (homosexuals). As with all herbs, women should never gather it during their moon time or during menses. The root is found in 2 colors that represent the 2 sexes of the plant. A salmon-colored root is the male root, while a crimson red color is the female root. The sex of a bloodroot can be determined by tearing the tip of the leaf which will bleed either salmon (male) or crimson (female). When using the root, you match the sex of the plant to the sex of the user in most cases.

Rehydrating the dried root

Place a quarter-inch slice of dried or dehydrated root into a half cup of water, and allow it to stand overnight. The rehydrated root can then be used for skin painting or for applications that call for it to be used on the wrists or neck.

For applications that call for powdered root, it is best to use the dried root.

Menopause, female hormonal imbalances, PMS, menses

Bloodroot's primary use is for female complaints during menses or in menopause. For missed menses or heavy menses, it regulates the flow. It is sometimes used for abdominal cramping, but Black Cohosh is better for this. It helps with PMS and regulating female hormones. For menopause and other female complaints, it can be used in a tincture form, but you should only use a tincture that has been cut back ten times from the mother tincture. (See directions for doing this in the

section "Cutting Tinctures," page 31.) The tincture can then be taken 3 to 5 drops under the tongue, three to four times a day.

More often, the fresh or rehydrated root is used to rub on the skin, where it is absorbed transdermally (through the skin). Older women would use it to paint the part in their hair, their fingers, around their eyes, and a big dot on the back of their necks. All of these were ways of getting the herb into the system to help balance the hormonal energies. The root is rubbed on the wrists to control hot flashes, mood swings, body hair, and facial hair during menopause. Women also used it as a red underline under their eyes. This helped as a women's remedy and also provided protection from the sun's glare when they were working outside.

Bloodroot is good for use by women who are trying to get pregnant. The fresh or rehydrated root is used to ease pain at the base of the skull and back of the neck. The medicine is then absorbed through the skin.

Liver

A tincture can be made from the fresh leaves. This tincture should be cut back once from the mother tincture. It is used to stimulate a sluggish liver by taking 1 drop under the tongue, five to six times per day. This tincture can be toxic in high doses and can cause tunnel vision that can last for 2 to 3 days.

Runny nose, nose congestion

The root is powdered to a face powder consistency and inhaled like snuff to dry a runny nose.

Warts

Fresh or rehydrated Bloodroot is also used externally to rub on warts to dissolve them. The dried root can be powdered to a face powder consistency and added to a salve or ointment.

Toothpowder, plaque build-up

The broken Bloodroot is also rubbed on the teeth to prevent plaque build-up. It is still used as an ingredient in many modern commercial brands of toothpaste and mouthwash.

A good toothpowder can be made at home by mixing a 1-pound box of baking soda with:

¼ ounce Bloodroot

⅓ ounce Goldenseal root or ½ ounce of Goldenseal tops

1 ounce Echinacea root

Each of the herb roots should be finely ground to a face powder consistency and then be thoroughly mixed with the baking soda.

Paint and dye

The rich colors of bloodroot make it an excellent dye. It was used for dying clothing and hides, basket splints, porcupine quills, moose hair, and anything that was worn ornamentally. Be careful when digging this root, because it will permanently stain clothing. As with other dyes that we will discuss, urine was used to make the dye colorfast. The roots can be boiled in water with human urine added to set the dye. You can also break the root and use it like a magic marker to draw designs or apply it to the skin.

Men used the dye as a warpaint or ceremonial face paint. Because men used this as a war paint, only the women were allowed to gather it. The women had control over when and why the men went into battle.

Face painting was one of many lessons learned from the wild turkey. The wild turkey is considered a bird of war. He changes the color of his face and taught the Muskogee people how to paint their faces. He taught them how to use blowguns and how to have war.

He also brought them the Little Brother of War which is the lacrosse game. The Muskogees used to play lacrosse with 500 people on each team. The center of town was the goal, and you usually played against another town, so the goal posts could be 30 miles apart. There were no referees, few rules, and it was often used as the way of settling minor

differences or arguments. If someone had killed your dog, you just grabbed a stick and joined the game. They had 2 sticks with little baskets on them, and they were all chasing a ball the size of a golfball.

Charm

Bloodroot is also carried as a charm for gambling, hunting, fishing, and for a love potion (hunting for a mate). The charm or fetish root is typically worn around the neck or carried in the pocket. It helps the person wearing it avoid arguments or enhances cooperation in interpersonal relationships. In the old days, it was used as a love potion by rubbing it on the palm of the left hand. Then whatever palm they touched next, that person would fall in love with them. They used the left hand because it was closer to the heart.

False Solomon's Seal

Smilacina racemosa

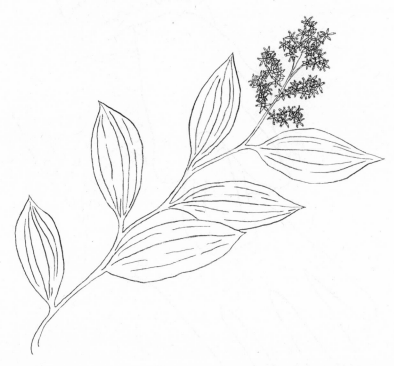

False Solomon's Seal has a similar leaf and stem structure to the True Solomon's Seal plant. Both have a long single stem with alternating lance-shaped leaves. The stem tends to droop over as if the plant is top-heavy. The noticeable difference is in the flowers, berries, and roots. In False Solomon's Seal, the flower (and later the berries) are located at the end of the stem, growing out of the top and only located on the stem end. In true Solomon's Seal, the flowers and berries hang down from the leaf axils in pairs. The root of the False Solomon's Seal is smaller has a dark brown to medium brown color, while the true Solomon's Seal has a white to light beige root that is usually thumb size or bigger. The root of False Solomon's Seal is the primary part used.

False Solomon's Seal is not commonly found in herb stores. It is also rarely found in Western herbalist literature. It has been documented in Chinese herbalism and is widely used in Native American herbalism. Interestingly, both the Chinese and Native Americans independently developed similar uses for the plant.

PMS, mood swings, calming babies, tension headaches

For most symptoms, the root of False Solomon's Seal is burned and the smoke is inhaled. It is used to balance mood swings of PMS and during menopause and to treat any type of anxiety or depression. It balances nervous energies and provides fast relief for anger, pain, and moods that reach the level of hysteria. It is beneficial for people who have a mean streak or who are harsh and mean when it is not necessary. Wafting the smoke toward a person who has fainted will peacefully revive them. The smoke is also good for relieving tension headaches.

The nutty smelling smoke is used for babies who are crying for no reason. They don't want to be held, fed, or need a diaper change. They are

 just crying uncontrollably. This makes others in the house crazy and irritable also. Traditionally, the root was burned and the smoke wafted over the baby, other children, and adults. Native Americans often kept this on the cradle boards with Sweet Leaf to calm children.

Survival food, digestive problems, diaphoretic

The root is highly concentrated in complex sugars. It makes an excellent survival food. Eaten raw or made into a tea, it helps in the regrowth of intestinal flora when recovering from antibiotic treatments that kill off the good and bad bacteria. The root tea is also used for stomach aches, constipation, rheumatism, and to promote sweating and urination. The tea can be used externally on the breasts for sensitivity from nursing.

Invisibility

The root of False Solomon's Seal is carried as a charm to achieve invisibility. It doesn't make you transparent, but people won't notice you. We carry it in the woods when we are gathering plants so that no one will bother us. It is also used for people who are in abusive relationships. It allows them to get out without being noticed.

This can be a mixed blessing. If you carry it while driving a car, you may avoid a speed trap because the police don't notice you, but that semi or car changing lanes may not see you either. Be careful when carrying the root.

Echinacea

Narrow-leaved Purple Coneflower, *Echinacea augustifolia*
Purple Coneflower, *Echinacea purpurea*

Also known as Ohio Thistle or Snake Root, all Echinacea have a purple, daisy-like flower and drooping petals. It is one of the Muskogee Seven Sacred Plants and again has many uses.

Since the early 1990s, Echinacea has been a fad plant and has become the most over-prescribed herb. It must be used with more caution. In most cases, it should not be used for more than 7 days in a row. For chronically ill patients, it can be used for 14 days, but for most illnesses you should not use it for more than 7 days. If overused, the plant will start to cause the symptoms it was being taken to alleviate. We say that it begins to feed the disease. For persistent problems, take it for 7 days and then go off it for 3 days, then start 7 more. Keep repeating this cycle until the problem is corrected.

The root of Echinacea is the primary part that is used.

Drawing agent, bites, stings, sores, abscesses, blood poisoning

Echinacea can be made into a tea, a tincture, or chewed and applied directly to wounds as an excellent drawing agent. It is used for snake bites and venomous insect bites including black widow spiders, brown recluse spider bites, and bee stings. It is also used to draw the poisons out of sores, boils, and abscesses.

Echinacea is best used for these by chewing the root and applying it directly to the point of injury. It absorbs a lot of poison but sometimes, depending on the severity of the poisoning or puncture or age of the wound, you may need to make several applications. Like anything else, it can only absorb until it fills up, and then it needs to be replaced by a new application to finish the drawing process.

Echinacea is considered a blood cleanser that is used for blood poisoning. When the red streak of blood poisoning appears, chew and apply the root to the point of injury. The red streak will begin to disappear and go down like a thermometer. It is good for general detoxifying of the blood system. Echinacea is also being used in the treatment of Lyme's disease. It is very good for wounds and cuts that are hard to heal.

Pain relief, toothache

Echinacea works to deaden the nerves to relieve pain and has an antibacterial and antiviral action to heal the problem. For new mothers, it can be used for wounds and bites on the breast from nursing. It is an excellent toothache and abscess medicine. It can be used as a tincture, tea, or chewed root to pack the tooth and gum area. First, rinse the mouth with peroxide. Place 1 tablespoon of ground Echinacea root into a shot glass. Add enough hot water to make a paste. Dip a cotton ball into the paste, and pack the tooth or abscessed gum area. You can also soak a cotton ball in the tincture or a strong tea and pack the area.

Tumors and skin cancers

Warning: Always seek professional help.

Echinacea has been used to help shrink skin tumors and numbs associated pain. It is considered to have anticancerous properties. The powdered root is made into a paste by adding water. The paste is then applied directly to the skin. The poultice should be kept on the tumor for about 2 hours. This process is repeated twice a day.

For internal tumors, a tincture of Echinacea is used. Dosage should be from 5 to 25 drops of the tincture taken five times per day. This kills parasites that are also involved when cancer is present.

AIDS, herpes, immune system

Echinacea is considered antiviral and is being used by AIDS patients for its ability to stimulate the immune system. The antiviral properties also make it a good remedy for canker sores and herpes sores. It is effective on any kind of herpes, whether it is chicken pox or oral or genital herpes.

Itching

Echinacea is used for itching problems and is often used in mixtures for treating poison ivy, poison oak, poison sumac, or even chicken pox.

Burns

A tea from the root is used to treat burns. The lukewarm tea is slowly irrigated over the burned area to deaden the nerves and reduce pain.

Solomon's Seal

Polygonatum biflorum

The Muskogee people learned about Solomon's Seal from the Wolf. By observing animals in the wild and studying what plants, roots, and barks they used for food and medicine, the Muskogee people learned about many uses for plants from the different animals that used them. The Wolf was observed using the root of Solomon's Seal whenever he had stomach problems. If the Wolf had eaten too much or had eaten old meat or something hard to digest, he would dig and eat the roots. The Muskogee refer to Solomon's Seal as a Wolf Medicine. I have also heard that the German name for Solomon's Seal translates to "Wolf's Milk."

Solomon's Seal is also known as High John the Conqueror Root. It is used as a charm, especially in the southern U.S., to give you power over your enemies. It is used to divert the evil intentions of those who consider themselves to be your enemy. It is worn on a string around the neck where it is close to your heart or sometimes carried in your pocket. It was often traditionally carried when people had to go to court. It is also carried as a charm for arthritis relief and is used by Blood Stoppers as a charm to stop bleeding. When carrying the root as a charm, the root should be replaced with a fresh root every 3 months.

Doctrine of signatures

Solomon's Seal is a good plant for demon-strating the doctrine of signatures. The plant shows us that it is useful for general fatigue, because it cannot stand on its own and droops over from its own weight. Another good signature from the plant is in the root. It grows in sections divided by the "seal" that resembles a bone and joint. Like our bones and joints, each root has a unique look. Some pieces look like the spine, arthritic joints, or like a finger with knuckles.

Fatigue

The top part of the plant is used for extreme fatigue. The leaves are put into alcohol right away. It is best to tincture this in the field. Fill a mason jar as full as possible with the leaves, and cover them with grain alcohol. Store for 7 days and shake it twice every day. The leaf tincture provides a pick-me-up that is similar to Ginseng. It helps get your blood sugar back in balance and provides a burst of energy from carbohydrates. It is useful for people who experience a late afternoon energy crash. The tincture can be taken under the tongue for an energy boost that will get you through the work day. The action is similar to an afternoon cup of coffee but without the caffeine side effects.

The root can also be chewed for fatigue. It contains natural sugars that also provide a burst of energy. The leaves have different sugars from the root.

Digestive tract

The root is used for people who have received a treatment of antibiotics and have resulting bowel problems. Eating the fresh root will help restore the friendly bacteria in the digestive tract that the antibiotics can kill off. It is used in the same way for bouts of indigestion and upset stomachs to calm and restore balance to the digestive system. If included periodically in your diet, it can help maintain a healthy colon and bowel. The root tea can be used as a mild laxative.

For most applications in the digestive tract, the root can be eaten raw when fresh, or dried roots can be rehydrated by soaking them overnight in water and then used as you would a fresh root.

Skeleton—bones, joints, muscles, and tendons

Warning: Isopropyl alcohol liniments should only be used externally. For internal applications, a grain alcohol is used.

The root is used as a poultice or mixed with isopropyl alcohol and used as a liniment for sprains, back problems, and misaligned bones. It may also be applied as a poultice for sprained necks or whiplash and as a liniment for ruptured discs.

It makes a good active ingredient in liniments and salves that are designed for back pains, muscle sores, sprains, joint problems, fallen arches, arthritis, and rheumatism. It shows the small bones how to realign themselves.

Used with Lobelia, it works on carpal tunnel problems to show the little bones, tendons, and muscles how to fit back together to reduce the pain. It is used on the wrist by applying hot packs and also taken internally as a tincture or tea.

Applications

Solomon's Seal has a sweet-tasting root that is effective when eaten raw.

Solomon's Seal root can be used as a liniment or salve for an external rub only.

The root can be made into a tea or tincture that can be taken internally or used as a wash or poultice externally at the same time to attack severe pain or recurring problems.

Also, the root can be crushed to a powder a mixed with oil, lard, or beeswax to use as a salve.

For a ruptured disc or torn, weak, or damaged connective tissues, use Solomon's Seal internally, either chewing or as a tincture, and externally as a liniment or salve.

Solomon's Seal, when used as a liniment, has the effect of shrinking tendons in the back. If you go to a chiropractor for an adjustment and your adjustment goes out within the first 24 hours, it might be because the tendons or ligaments are so stretched out that they allow joints to slide in and out. Solomon's Seal liniment is a good follow-up to a chiropractic treatment.

To make a good general liniment for external use, take a bottle of rubbing alcohol (isopropyl alcohol), and pour one-third of it into another container. Then fill the original bottle back up with Solomon's Seal roots. Just break them, put them in the alcohol, and let it sit for 7 days, shaking it twice a day. It will start to turn brown after 4 or 5 days. After 7 days, it is ready. It should be used topically. When all the alcohol runs out, you can fill it up again with alcohol at least three times. Each time, after 7 days it will turn a nice golden color. You can also add Ground Nut and/or Mullein stalk to the liniment for extra pain relief. This liniment is helpful in strengthening tendons.

Bleeding

The root is also used to control bleeding from wounds, internal bleeding, menses, and arterial bleeding. The ground root is used externally as a poultice on open wounds, and the tincture is used internally. If Solomon's Seal doesn't work, go to Goldenseal to control bleeding.

For first-aid in the field, clean a wound thoroughly and then apply chewed Solomon's Seal root to the cut or wound.

Solomon's Seal roots were often gathered and presented to the bride as a wedding gift.

Muskogee bride

Snake bite remedy

Solomon's Seal root grows where rattlesnakes live and hunt. The fresh root can be pounded and applied fresh to a snakebite wound. It is 1 of about 40 plants found in the wild that can be used for emergency treatment of snakebites.

Mixtures

Solomon's Seal tincture is mixed equally with tinctures of Wild Bergamot and Boneset for a flu and cold remedy. The Solomon's Seal works to clear the lungs and to treat coughs. It also helps reduce the aches and pains associated with flu symptoms.

Solomon's Seal and Boneset tinctures are mixed with a pinch of Lobelia to treat chipped bones, painful old bone breaks, and loose bones. This mixture should be used for 1 week on and 1 week off and repeated as necessary. (Always consult a practitioner. Never self diagnose.) Stay away from refined sugar and caffeine while taking this.

Solomon's Seal tincture is mixed in equal parts with False Solomon's Seal tincture to treat depression and a deep brooding state of mind. Adjust the dosage from 1 to 3 drops, three times per day, depending on the severity of the depression.

This same mixture (equal parts True and False Solomon's Seal tinctures) is also used as an appetite suppressant. The mixed tinctures are taken 3 to 5 drops per dose. Take it 15 minutes before eating either meals or snacks. It can also be taken at the halfway point between meals or when you are most likely to snack. If you have the urge to eat or snack, take 3 to 5 drops under the tongue and wait 15 minutes before eating.

Foods

Solomon's Seal is gathered for wild food. The root is the original sweet potato of North America. In fact, the sweet potato pie was originally made with Solomon's Seal root, wild Ginger, Sassafras, and Marsh Mallow plant.

Solomon's Seal is also used as a preservative for oil-based herbal mixtures. It helps keep the natural oils from becoming rancid.

Solomon's Seal was highly valued by native tribes of the East. Patches and fields of Solomon's Seal were fiercely guarded by tribes, and wars were fought to protect collecting rights.

Calamus

Sweet Flag, Bitter Root, *Acorus calamus*

Calamus root has a very pungent, bitter flavor. This is probably a good time to tell you that we believe you should never complain about the taste of a plant. We think this insults the spirit of the plant or medicine of the plant, and it may not help you if it has been insulted.

Doctrine of signatures

Calamus is another good doctrine of signatures plant. It grows in the swamp or bog in really smelly and sulphurous places, the coldest, dankest part of the swamp. The root also looks like a larynx. This shows us that it is good for colds and congestion, breaks up phlegm, and is good for the throat and voice.

Calamus is found worldwide. It grows naturally around the globe, in nearly every country and continent. It is quite popular in India and northern Europe.

Throat, voice problems, laryngitis

Calamus is used for throat and voice problems like laryngitis. The root is chewed and the saliva is swallowed and allowed to coat the throat. Don't drink anything for 20 to 30 minutes after you use it; just let it coat the throat. When you go to powwows, you will see people sitting around the drum with this root hanging on a string around their necks. They chew and suck on it throughout the day to help keep their voices strong.

A few years ago at a veterinary conference, the key speaker, a British herbalist, came down with laryngitis. He was scheduled to speak before 200 people, and that morning he couldn't raise his voice above a whisper. He approached me to see if I had anything that would help. I gave him some calamus and told him how to use it. We met again at the conference later that night, and he thanked me for this wonderful medicine. He said that it not only brought his voice back, but that he felt his voice was stronger and had a better resonance than before. I thought it was funny, because even the little kids at a powwow know how to use calamus. To make calamus more appealing to

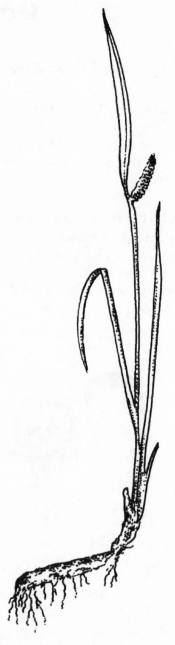

kids with sore throats, it is often rolled in sugar and kept like candy.

Toothaches, teething pains

The root is powdered to a face powder consistency and used to relieve toothaches or rubbed on a baby's gums to soothe teething pains. It numbs the pain and has an anti-inflammatory effect that

reduces swelling and controls drooling. The powdered root can be rubbed directly on the gums, or it can be soaked in a grain alcohol, then strained, and the alcohol is rubbed on the gums.

Arthritis

The root can be made into a tea and used as a hot compress for arthritis. Its anti-inflammatory effects are soothing for sore joints and back pains.

Accelerator

Calamus is an accelerator of other white-rooted herbs or those with white flowers. An accelerator is used in very small amounts in a regular single herbal formula or an herbal combination. It increases the power of the herbs without adding more herb or increasing the dosage. Accelerators make things easier for the body to assimilate, helping the body accept them faster.

Calamus and Flat Cedar expectorant & cough syrup

Warning: Cedar can be a natural abortive. This should not be used by pregnant women or women who have heavy menses. It's OK to use for infants and elderly.

Good for allergies with congestion, bad coughs with congestion, and pre-pneumonia conditions.

1 handful (½ cup ground) Flat Cedar
2½ inches of Calamus root, chopped but not too fine

Steep the herbs in 2 quarts of boiled water for 1 hour, 15 minutes.
Strain, but put the calamus root back into the liquid and store it in the refrigerator. The Calamus will continue to release oils into the liquid.
Drink 1 cupful.

After dark, the coughing will get worse. Any congestion and mucous will be coughed up. Be sure to spit this out. Swallowing the mucous will recycle the poisons into your body.

Sassafras

Sassafras albidum

Warning: The active ingredient in Sassafras is safrole. It is a blood thinner that can be very dangerous if improperly used. It should never be used by menstruating or pregnant women, hemophiliacs, alcoholics, anyone with blood in the stool, or anyone taking drugs that are blood thinners.

There have been incidents of death caused by the misuse of Sassafras.

Sassafras and any other herb should be treated with the same respect as any drug or prescription medicine. Always seek professional help and never self prescribe herbs. The FDA considers Sassafras a carcinogen because of laboratory tests on rats.

Doctrine of signatures

There are 3 different kinds of leaves on one tree. That shows there is something more to this plant than meets the eye. One leaf is shaped like a mitten, another is shaped like a glove, and the third is shaped like the sole of the foot. In the fall, these leaves turn bright red. This shows that it will make your hands and feet hot.

Body temperature

The Muskogee people used to gather the leaves of Sassafras, string them on a thread, and hang them in the house for the winter. In cold weather they would pull off 2 or 3 leaves, crush them up, and put them into mittens and boots. The powdered leaves draw the blood to the extremities and warm the skin right up. This is also a modern survival tip for preventing frostbite. Be very careful when using this technique. The oils from the leaves will burn your eyes, mucous membranes, and private parts very badly.

Taken internally, Sassafras tea can lower the body temperature by up to 5 degrees. Historically the native peoples used a root bark tea before a dance or as a summer cordial. It is good for use in the hot summer to prevent overheating, hyperthermia (hyperpyrexia, especially when induced artificially for therapeutic purposes), and heat exhaustion. An interesting point of contrast is that when used internally it lowers the body temperature and when used externally it raises the body temperature.

Blood pressure, cholesterol, blood tonic

The powdered root bark of Sassafras is made into a tea for any ailment where blood-borne toxins are a root cause and other ailments appear, such as stomach aches, bowel problems, gout, arthritis, rheumatism, liver and kidney ailments, and skin eruptions.

Sassafras works to take the fat out of the blood, lowers blood pressure, and lowers cholesterol. During the cold months, we need to have more fat in our blood, but in the springtime you want to flush that out. This was the basis for spring tonics. The root bark of Sassafras is a famous spring tonic, because it thins the fat out of the blood and helps the liver to drain off toxins. The tonic was used to prevent spring fever, which would occur after eating dried meats and dried vegetables all winter. Then when fresh meat and vegetables were eaten again in the spring, a person might experience a shock to the system. Often this resulted in headaches, stomach aches, fevers, and diarrhea. Some severe cases could lead to death.

Native people and the mountain people of Appalachia shared much knowledge. The Native people taught the mountain people about herbs, and the mountain people taught the natives about preservation of herbs using distilled spirits. Early Native American tinctures were made using the now-illegal moonshine from the southeastern mountains. Spring tonic was the lesson from the natives to help the mountain people through spring fever.

In modern society where people have access to fresh meat and vegetables all year long, spring fever is an ailment of times gone by. In the past however, spring fever was a serious condition which could bring death. This story should be passed on to our children, because it would be a difficult lesson to learn again.

The heartwood, found in the very center of the tree, was used to make a tonic for high blood pressure and heart ailments.

Bruises, circulation

The powdered root bark of Sassafras is made into a rubbing oil and applied to bruises. Even deep bruises of car accidents will fade quickly. Sassafras helps break up the blood clotting and dead tissues that cause the discoloration of bruises. The oil should not be used on blood clots of elderly people, because it can cause the blood clots to break loose and lead to strokes and heart failure. Again, this should only be used by a trained practitioner.

A rubbing oil can be made by adding 2 tablespoons of powdered bark into 6 to 8 ounces of olive oil or jojoba oil. Let the mixture stand for at least 30 days. Then strain the oil off, and use it as a rub for

younger people with cold extremities or poor circulation. Again, be sure that the problem is not related to blood clots that may break loose.

Cooking

If you cook the leaves of Sassafras, they turn into a thick gel-like phlegm. Just a few leaves will get very thick and mucilage like. This shows us that it is good for coughs where there is a lot of congestion and phlegm. Sasafras leaves are also used as a thickening agent in cooking. It is the filé in filé gumbo.

Sassafras makes an interesting spice and meat tenderizer. The root bark is ground to a face powder consistency and added to soups, stews, and pies. It was widely used as a spice before cinnamon was commonly available. In fact, it was the original spice used in pumpkin and sweet potato pies. It can be used to rub down a roast as a meat tenderizer. Cover the meat with the powder, and place it in the refrigerator overnight. It draws all the excess blood out of the meat and leaves it very tender.

Eyes

A tea made from the ends of twigs is used to bathe the eyes for some eye ailments.

Muscle regrowth

The following mixture of Sassafras, Ginseng, and Birch leaves can be used for muscle regrowth, even where the muscle has been severed.

1 ounce of Birch leaves
½ ounce powdered Ginseng root or 1 ounce leaf and stem
2 level teaspoons of powdered Sassafras root bark

Put the herbs into a quart jar, and fill it with a strong grain alcohol. Allow the tincture to steep for 7 days, then strain.

Take 1 drop under the tongue three to five times a day.

St. John's Wort

Hypericum perforatum

Warning: St. John's Wort can cause extreme sensitivity to the sun when used internally. It can cause severe sunburning in blond, red-haired, or other fair-skinned people.

It can also cause retinal bleeding or a detached retina of the eyes if used long term.

St. John's Wort should not be used by menstruating women, pregnant women, anyone taking medications that thin the blood, or if you are taking any kind of antidepressant drugs. It should not be used by anyone who is taking chemotherapy.

Doctrine of signatures

The plant grows from 1 to 3 feet tall, and the leaves are oblong in shape. The small flowers are in clusters at the ends of the upper stems. St. John's Wort is best identified by examining the underside of the leaves. Small translucent glands in the leaf give it the appearance of being perforated, hence the Latin name *perforatum*. Each leaf has hundreds of what look like tiny pinholes. Also, the tiny yellow flowers have dots around the edges of the petals, giving them a perforated look.

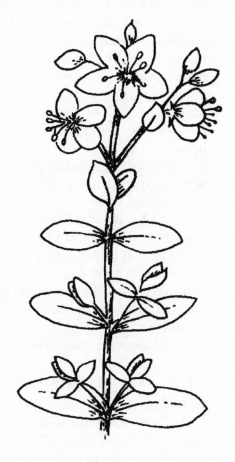

The word "wort" comes from old English herbalists, and it means a plant or a weed. This plant is called St. John's Wort, because it blooms on the feast of John the Baptist, June 24th. That is the best day to gather the plant. You can gather on other days, but that is when it is at its peak.

71

If you pull 1 of the yellow flower heads off and crush it between your fingers, it will bleed, leaving a red to purple stain. This is a signature of its relationship to John the Baptist who was beheaded.

Witchcraft and storms

The history of St. John's Wort has long been bound up with mysticism. It was used by the peasantry of Europe to ward off evil. They would hang it over the doorway to keep witches away or plant it along side-walks. If a witch walked next to it, they would fall down and have great trouble getting up and getting away. The Muskogee people figured out how to use the plant without being told by the Europeans. In the 1800s, the Cherokee people were hanging it over the door-way to avert evil.

The Ojibways would throw it on the hearth or burn it in the fire-place to make a storm dissipate. It is also hung on the door of the house or tied to the gale above peaks by English and Native people to divert lightning strikes. I've used it to divert severe storms and even used it on a boat once on the Great Lakes when the weather turned really bad. If you don't have a hearth, you can use a cast-iron skillet or pot to burn the herb, but if you're doing this in the house, you must open the windows for the smoke to escape.

Acne, skin eruptions, and wounds with nerve damage

This herb is specific to skin eruptions, acne, wounds, cuts, bleeding, and bruises, especially those with nerve damage. The blood-like juice of the herb is a signature that the herb is an effective wound healer. It was used in the Middle Ages to dress sword cuts and is still used for wounds, ulcers, and burns.

For acne, a tea is made out of the leaves, flowers, and stems. Use 2 large handfuls of fresh herb or 2 smaller handfuls of dried herb to 1 gallon of water. Boil the water first, then turn off the flame, add the 2 handfuls of the herb, cover, and let it sit covered until it cools down a little. You want it just as hot as you can stand it, so you can put your hand in it without burning yourself. Strain this off. Take a white cotton towel, and soak that in the tea. Wrap it on any area where there is bad acne such as the face or back. When you are done with the St. John's Wort, take Birch bark and tear it into shreds. Make a strong infusion or a tea out of the Birch, and use it as a cold spritz to close the pores. This can be used in very severe and long-standing cases of acne even where there is pitting, swelling, and inflammation. The hot pack of St. John's Wort will return the face back to normal in 2 weeks. Often this type of acne is caused by a bacterial and fungal infection. St. John's Wort will draw out the infections and help prevent recurrence.

Antiviral, antibiotic, anti-inflammatory

St. John's Wort is antiviral, antibiotic and anti-inflammatory. It is used internally for treatment of worms, diarrhea, dysentery, and bladder ailments usually associated with infections. It is also currently being researched for use in the treatment of AIDS.

Nerve sedative, antidepressant

St. John's Wort made headlines and the national TV news in the summer of 1997 when drug companies and doctors finally "discovered" that St. John's Wort is an excellent medicine for nerves and in treating depression. It was being tested and recommended as an alternative to Prozac and other antidepressants. The Muskogee people have been using it this way for generations. It is especially helpful as an antidepressant and nerve tonic for menopausal women to control mood swings and anxiety attacks. There are several warnings associated with use of this herb that you should review before considering it for use.

SAD, cabin fever

In northern climates where there is less sunlight and longer and colder winters, a common form of depression sets in that is called SAD or cabin fever. St John's Wort was recommended for this type of depression. Since there was little sunlight to worry about, the side effects of sun sensitivity were not a big concern.

Sweet Fern

Comptonia peregrina

Sweet Fern grows near where blueberries grow. It has a very fragrant smell. If you make a tea of the leaf, it is a good tonic. It usually does not need sweetener.

Doctrine of signatures
The roots of all ferns can be used interchangeably for a good hair and scalp rinse. The root, when rinsed off, looks like a clump of hair. Maidenhair fern is preferred for normal hair (it's more specific to it), but the other ferns bring something good to the scalp.

Fevers, refrigerant
Sweet Fern leaves are used as a refrigerant against fevers. They can be used to make a tea, or the fresh leaves can be crushed and placed against the palms of the hands, the soles of the feet, and on the forehead.

Use the leaf to line a basket for picking berries, because it repels the flies, even fruit flies. It also acts as a refrigerant in this situation, keeping the berries cool. The ones on the bottom will be just as fresh as the ones on top. The leaves will impart a slight flavor that makes the berries taste fresher.

Hair and scalp rinse, psoriasis, eczema
Sweet Fern root is used to make a hair rinse used more specifically for hair damaged by permanents, treated hair, for people who are losing their hair, and in a mixture for itching scalps.

Gather the root and rinse very well. The roots are pulverized, added to a gallon of boiled water, and steeped until they are room temperature. The liquid is strained off and used as a rinse after you wash your hair. It makes your scalp feel good and your hair feel healthy and improves its elasticity.

An excellent hair rinse
Combine:
>Pulverized Sweet Fern roots
>1 braid of Sweet Grass, cut into 1-inch pieces
>1 piece of pine gum about the size of a pigeon egg

74

Add these 3 ingredients to:
 1 gallon of boiled water
Cover and steep until it reaches room temperature. Strain off the liquid and use as a rinse after washing your hair.

The pine gum is full of balsam that helps if there is psoriasis or any kind of sore on the head. This rinse can also be used on other areas where psoriasis or eczema are a problem and will make the skin smooth and supple. It takes out the itch.

Usually this rinse would be used on a full moon, not a new moon. All the girls would get their hair cut and washed, then rinse this in. Then they wouldn't wash their hair for 5 days. The rinse would be absorbed by the roots and give the hair a healthy sheen. After 5 days, they could wash their hair as usual. That would make it thicker and grow faster.

Scaly scalp, cradle cap

Sweet Fern is especially good for babies with cradle cap, older people with really scaly scalps, or other people with a reaction to a food allergy or some other contaminant that causes scaling and itching of the scalp. Whenever there are sores, Sweet Fern is preferred. It will heal.

Skin rashes, sunburn, insect bites, stings, acne

A leaf tea is used externally to treat poison ivy rash. Steep finely chopped leaves in boiled water for about a half hour, and then strain. Use this tea as a poultice or compress on the rash. When rubbed on severe poison ivy rash, the healing will start almost immediately and will stop the itching.

The tea is a mild astringent that can be used as a compress for sunburn, acne, insect bites, and stings.

Dysentery, intestinal cramps, diarrhea

A strong leaf tea is used for dysentery, relief from diarrhea, and intestinal cramping. Use 1 palmful of the leaves steeped in 2 quarts of boiled water for 45 minutes. Take 1 cup of tea three to four times per day.

Boils

For boils, Sweet Fern leaves are mashed and mixed with a small amount of water to make a thin paste. It should look like equal parts of herb and water. Simmer this mixture into a thick paste to use as a poultice. Put the warm mixture directly on the boil, and let it cool. Repeat the warm poultice as often as necessary until the boil ruptures. Then wipe clean with milder astringent tea.

Teeth, gums, periodontal disease, mouth sores

A very strong tea is also used as a mouthwash for gum problems, periodontal disease, and mouth sores.

The pulverized leaves can be used for toothpaste.

Convulsions

The leaves are used to make a strong tea, and the tea is added to a lukewarm or cool bath for people who have convulsions. If possible, they can be immersed in the bath while the convulsion is occurring. A cool towel soaked in the tea can be used around the chest and abdomen of a person who is experiencing a convulsion.

Food poisoning, nervous stomach

A tea or tincture of the leaves can be taken for food poisoning or a nervous stomach. Take 1 ounce of tea, two to three times during the first hour of stomach discomfort. If a tincture is preferred, use 1 to 5 drops under the tongue.

Bad smells

In the wild, the leaves of Sweet Fern are rubbed on the hands to remove any foul smells.

Edible

A tea can be made using 1 teaspoon of dried leaves steeped in a cup of boiling water. (Do not use the stems.) Older leaves make a stronger tea, and younger leaves make a sweeter tea. The needles can be separated from the burrs and eaten raw. Gather these in June and July.

To gather the leaves for storage, pick the leaves in summer. Sort out damaged leaves and sun-dry the rest until still green in color but slightly brittle. Place them in cheese cloth bundles, and dry the rest of the way, then place in earthenware jars.

Sweet Fern Tea: Sun tea can be made by using 8 teaspoons of fresh leaves per 1 quart of water. Cap and place in the sun until dark. Strain and dilute to taste; sweeten if desired.

Tansy

Tanacetum vulgare

An erect perennial with button-like, flat, bright yellow flower tops, approximately half an inch wide, composed entirely of disk flowers with occasional ray-like extensions. The leaves are approximately divided into linear, toothed segments. STRONGLY AROMATIC. The plant grows to be 2 to 3 feet tall and flowers from July through September. It grows throughout the U.S. along roadsides and field edges.

Warning: This plant contains tanacetum, an oil that is toxic to humans and animals. It is a natural abortive that can be fatal to both the mother and child. It should never be used by pregnant women.

Worms in people and dogs

Tansy is used to expel worms in adults, children, and dogs. If you have tried milder remedies but cannot get rid of the worms, then try tansy. It is an excellent worm preventative for dogs and will kill any type of worm, including tapeworm and heartworms.

Tansy can be toxic and many people have a bad reaction to it. Tansy contains tanacetum, an oil that can be toxic to animals and humans.

Add 1 ounce of the dried herb to 2 quarts of boiling water, and remove from the heat. Cover and let steep for 90 minutes. This should be given with food twice a day, morning and night, for 4 days in the following doses: for adults, use ½ ounce; for children and larger dogs, use ½ teaspoon. Reduce dosages according to the size of the patient. Since we believe that worms become more active during the full moon, this is the best time to apply this treatment. Try this remedy for 4 days before or during the full moon phase.

Menses

Tansy can also be used internally to promote menstruation, if you are sure you are not pregnant. This should only be used by a trained practitioner and then only after a pregnancy test has confirmed that you are not pregnant. Usually an infusion is given before food in 2-ounce doses, three times a day.

Gout, swollen feet and ankles

Externally, Tansy is used in a steam bath for swollen feet and ankles. Also, ½ teaspoon of dried seeds are infused in hot water and used for gout.

Headaches

For headaches, the plant was beaten and bound on the head.

Insecticide

Tansy also makes an excellent insecticide that helps keep fleas and flies out of the house and off your pets. Put some Tansy and Pennyroyal in a muslin bag and crush them together. Every time the dog goes out rub it all over with it. It can also be used in stables with horses. You can even tie it to their bangs to keep the flies out of their eyes. You can also powder horses down with it.

For the house, take that same bag and hang it over the doorway. Every time someone goes under the bag they crush it and that keeps

flies from hanging in the doorway and getting inside. These same bags or the loose Tansy and Pennyroyal are used where you store linen and clothing to keep bugs away.

Sties and varicose veins

For sties of the eyes or for varicose veins, use a cloth dipped in a tea as a compress. Add 1 teaspoon of the dried herb to 1 cup of boiling water. Steep for 10 minutes and strain off the herb. Apply as a warm compress to the eye or vein area.

Dye

An orange dye is made of Tansy, chrome, and cream of tartar.

Food

Fresh young leaves and flowers can be used as a substitute for sage in cooking.

Caution: Do not use at all if pregnant.

Tansy pancakes:
 1 cup plain flour
 pinch of salt
 1 egg
 ⅔ cup of milk
 1 teaspoon chopped tansy
 butter for frying
 sugar

Sift the flour into a bowl with the salt. Beat the egg and milk and then the chopped tansy leaves. Leave the mixture to stand for a little before using. Melt a little butter in a frying pan and use the batter to make 4 pancakes. Roll and sprinkle with the sugar.

Tulip Poplar

Tulip Tree, *Liriodendron tulipifera*

Very little is known about this plant by Western medicine. It is not generally found in herb stores or catalogs and is usually gathered as needed by barking the limbs of living trees. With practice, barking can be done safely when the sap is running without harming the tree.

Utensils, canoes, housing

The Native people used the bark for many household items such as making baskets and trays and containers. It is super strong. The bark is very pliable when it first comes off the tree. Within the first few hours, it can be bent, shaped, drilled and, with a pocket knife, you can carve designs into the supple wood. While fresh, the bark is molded or shaped into the desired form and then tied or bound to hold the shape until it dries.

Huge barge canoes were made out of the largest trees with some boats being 40 feet long. These boats were much more durable than the birch bark canoes of the north and would carry more weight and endure rough water.

Muskogee people also used flattened sheets of bark to face off their houses, like modern shingles or siding.

Another important use was to make rattles that were used for doctoring and ceremonies. The Muskogee people believe that in the beginning of time there was a dark void and only the Creator. Then there was a sudden flash of light and the sound of a shaker or rattle. This pulsating light and the sound of the shaker is in every one of us and in every object. It is the vibration of sound and light that is in everything.

Heart tonic, cholesterol, and blood tonic

Tulip Poplar, as a medicine, is particular to the heart. It has a tonic effect, cleaning plaque slowly from the inside of the arteries, so it is useful in hardening of the arteries. A tincture is made by soaking strips of the inner bark in a strong alcohol. Keep it in an airtight container for 7 days, and shake the mixture twice a day. After 7 days the liquid is strained off and used as a tincture. Take 3 drops of the tincture under the tongue three times per day.

This is good for people recovering from a stroke, people with pre-heart attack conditions, or those who have suffered several heart attacks and/or bypasses.

Animal medicines—Bear medicine

Tulip Poplar is considered a Bear medicine. It can be used in 3 or 4 different ways. If you look at the tree, the leaf looks like bear paws. The bark looks like a bear scratched it all the way down. The bears use this medicine as a heart tonic.

Sutures/stitches

Splinters of Tulip Poplar would be used to suture wounds just as we would use stitches today. The inner bark has antibiotic and anti-inflammatory properties that help keep down the infection while the wounds are healing. If there was a concern of reinfection, it would keep the area clean. The splinters could be removed after the wound healed, like modern stitches.

Most literature represents the native healing practice as being very primitive by today's standards, but new evidence is being found that the ancient civilizations had many forms of surgery, even brain surgery, that were amazingly successful.

Fatigue

A splinter of Tulip Poplar inner bark is chewed for fatigue. For this to be effective as a medicine, you have to be up walking around for it to get into your system. Otherwise, the medicine just sits there in the mouth and digestive system and can cause blisters in the mouth if misused.

Violet

Common Blue Violet, *Viola papilionacea*
Canada Violet, *Viola canadensis*

Warning: There are many varieties of wild violets. Some are extremely rare and are protected in the wild. Be aware of the regulations in your area for gathering and possession of plants. Some varieties of violet are illegal to gather or possess.

Doctrine of signatures

The leaf shape indicates that they are good for the heart. The branching pattern of the stems indicates they are used for bronchial problems. The cold, damp area where they like to grow is a signature that they are good for respiratory problems.

Accelerator

Violets are an accelerator of green medicines. As such they are added at a ½ teaspoon dose to 2 quarts of another medicine. (For a complete explanation, see the "Accelerators" section in the chapter "Some Words of Caution" on page 14.) Use caution when taking this medicine, being aware that it may interact with other herbs that you take by acting as a catalyst.

Bladder pain, prolapsed bladder, prolapsed uterus

A weak root tea is used for pain in the bladder region and in the lower abdominal area, especially those discomforts due to slow or stagnant blood. It is used for treatment of a prolapsed bladder or prolapsed uterus.

Boils, carbuncles, pus-filed sores, swollen glands, antiseptic, cold sores

The roots, leaves, and flowers are mashed and pulverized and used as a poultice on an area affected with boils, carbuncles, pus-filled sores, or swollen glands. The poultice will have a drawing action that pulls out any infection. Keep the area warm by covering it with a flannel cloth. The leaves can be applied directly to any area where an antiseptic is needed.

Emetic, induces vomiting, prevents gagging, morning sickness, stomach pain, diarrhea

The roots and leaves are used as a tincture or a strong tea to induce vomiting. They can be a powerful purgative. It is used for people who have a feeling of being sick but who can't throw up.

In low doses, the same tea or tincture will prevent gagging or morning sickness. Low doses can also be used to sooth stomach pains and stop diarrhea.

Heart—slow or sluggish, angina

The violet flowers are made into a tincture and cut back five times from the mother tincture. (For more information about cutting back, see the section "Cutting tinctures" on page 31.) In this minute dose, the tincture is used to treat angina or a slow and sluggish heartbeat. This should only be used by a trained practitioner.

Cancer, cancer pain

A strong tincture made from Violet leaves is used in very small doses for cancer of the uterus and breast. The tincture discourages the growth of new blood vessels, veins, and capillaries that feed the cancer. The tincture dosage is 1 drop taken under the tongue, four times a day.

For pain associated with cancer, the same strong tincture is used. To start, when a pain episode occurs, use 1 drop under the tongue every 15 minutes until the pain subsides. After the first day, the body will adjust so that 1 drop should relieve the pain.

Warning: Cancer is a serious problem that should only be attended by a trained professional. As with all illnesses, do not attempt to treat yourself.

Pleurisy, bronchitis, coughs, expectorant

A weak tea is made by adding ⅛ ounce of Violet leaves to 2 quarts of boiled water. Remove from the heat and let steep for 1½ to 2 hours. Strain off the liquid and store in an airtight container. For pleurisy or bronchitis, take 1 to 1½ ounces of the tea five to six times a day.

For coughs and as an expectorant, use the same tea but add brown sugar or honey to thicken. Take this in tablespoon doses five to six times per day. As with all cough syrups, do not drink any liquids for 15 minutes after taking the syrup to allow time for the throat to be coated.

Varicose veins

Violets have an astringent property that helps strengthen the walls of varicose veins and relieve the pain. They can be made into a tea and used as a compress or added to a pint of isopropyl alcohol to make a liniment. Use 1 handful of crushed leaves and flowers to make a strong tea or liniment. Apply to the area as a compress or rub in the liniment every day until the problem goes away. With most varicose vein treatments, it takes 3 to 12 months to restore the veins to a healthy condition. The pain will go away more quickly, but continue using the liniment until the veins fade.

Increase milk production

To increase milk production in nursing mothers, mix:
 2 tablespoons of hops
 1 teaspoon of violet flowers

Add the mixture to 1 quart of boiling water, and steep for 30 minutes. Strain the tea and add honey to sweeten if desired.

Drink 1 cup several times a day. Because violets are rare, it is better to substitute parsley or milkweed for this use.

Chapped lips, cold sores, skin lotion

Violets are high in vitamin A and in a lotion are very soothing to the skin. They also have antiseptic properties that make a good lotion; stiffen the lotion with beeswax to use for chapped lips and cold sores. Fresh sage makes a good addition also.

Edible

You should remember the warning about some varieties being rare and protected. Always make a positive identification before ingesting any wild food. Violets have many poisonous look-alikes. The leaves and flowers of most Violets are edible. They can be used in salads or as mixed greens. The flowers were often used as candy when dipped into an egg-white mixture and then sugared. They make a pretty treat. The flowers are also used for making jelly and syrup.

Wintergreen

Gaultheria procumbens

Warning: Do not use the tea or tincture internally if you have ulcers. Use caution when applying liniment or oils externally. Wintergreen contains volatile oils that get under the fingernails and cling to the hands. Do not rub your eyes or mucous membranes after handling this plant. Do not use in a bath.

Doctrine of signatures

Wintergreen lives through both severe heat and cold. The volatile oils will burn your mouth, skin, and mucous membranes, and will burn when lit with a flame. It also has a very sweet smell and taste. The berries are bright red and signify the redness associated with cold sores or inflamed joints. The berries are also very bitter before the first frost, a sign that they are good for the liver.

Liver cleanser

Wintergreen berries are gathered before the first frost while they are still bitter. They are dried and soaked in a strong grain alcohol to make a tincture. This is used as a liver cleanser for people with food poisoning or alcohol poisoning. It should only be used by a trained practitioner and should never be used by people with ulcers.

Joints, muscles, sprains, rheumatism, gout

A liniment is made by adding ½ ounce of Wintergreen leaves to a pint of isopropyl alcohol and letting it stand for 4 days, shaking it twice a day. The liniment can be used for sprains, achy muscles, and sore joints and is for external use only.

An external oil is made for rheumatism, gout, sprains, strains, or for use as a massage oil.

Mix:

> 1 ounce of mixed leaf and berry
> 2 quarts of olive oil

Bake in the oven at a very low heat (150°F) for 4 to 5 hours. The leaves should become crunchy when done. Strain or press off the oil, and store in a dark jar.

Caution: Do not use oil or liniment on rashes, skin abrasions, or cuts.

Cough drops

Cough drops can be used for sore throats, strep throat, tonsillitis, any mouth sores, mouth and tongue burns, or bites. Use ½ ounce of Wintergreen leaves added to 1 quart of boiling water. Remove from the heat and allow to steep for 1½ hours in a covered pan. Strain off the liquid and put it back on a low heat. Add 2 to 4 cups of sugar slowly, and stir until the sugar dissolves. Remove the mixture from the heat. As it begins to cool and thicken, roll it into little balls and place on a greased cookie sheet. When the drops are completely cooled, they can be wrapped in wax paper individually for easy use.

Cold sores, fever blisters

A 50/50 mix of Wintergreen with either Sweet Fern or Sweet Leaf can be used to make an ointment for cold sores and fever blisters.

Tooth powder

Dried leaves and berries are powdered into a face powder consistency and added to a tooth powder mix. Use a base of baking soda, and mix in finely powdered herbs such as Bloodroot, Goldenseal, and Echinacea to meet your tooth and mouth needs.

Description

Wintergreen, also known as Tea Berry, is a low growing, creeping shrub about 2 to 6 inches high that has upright branches with white urn-shaped nodding flowers, either singly or in groups of 2 or 3. The flowers are about ⅓ inch long with 5 fused lobes. The leaves are shiny dark waxy green about 1 to 2 inches long, oval,

and slightly toothed. They have a wintergreen scent and flavor. The fruit is small, red pulpy berries with a spicy taste. Wintergreen grows in oak woods and under evergreens, preferring sandy, acidic soil. It flowers from April to May and the berries may stay on through the winter. They are best if gathered after the first frost.

Fevers

A tea of equal parts Yarrow and Wintergreen is good to use for bringing down fevers.

Edible

The leaves can be picked throughout the year and used to make a very refreshing tea. Cover the leaves in boiling water; tearing them seems to help release the flavor. (DO NOT BOIL THE LEAVES IN THE WATER. This will cause too much wintergreen oil to be released, and the oil is mildly toxic.) Leave to steep for a day or two. Reheat before serving. I like to add a few berries in with the leaves to add to the flavor. The leaves can also be eaten raw as a trailside snack, but limit it to a small amount, as the leaves contain a high amount of Wintergreen oil which has an aspirin-like substance in it. New leaves can also be added to salads or used as a spice in cooking. Fruits are best gathered after the first frost and can either be eaten raw or used in pancakes, fry bread, ash cakes, or muffins. The berries are also good to use to spice up soups and stews.

Food preparation

Winter Green Jam: If the berries are plentiful, they can be used in this recipe, but do not over-harvest if the berries are sparse. The berries become sweet after the first frost.

Combine in a blender:
2 cups of fresh ripe berries
1 ounce lemon juice
1 cup STRONG Wintergreen tea

Blend until smooth, pour into a mixing bowl, and add 4 cups of sugar. In a saucepan, bring to boil 1 package of pectin and ¾ cup of water. Boil 1 minute and add the berry mixture; mix well, spoon into sterile jars, and seal. Store in the refrigerator or freezer.

Yarrow

Achillea millefolium

Warning: Yarrow acts on the blood by increasing the blood flow and speeding up the clotting process. It is also very high in potassium which in large doses can cause headaches, giddiness, and heart problems in a pregnant woman and her unborn fetus.

Yarrow should never be used by pregnant women, hemophiliacs, people taking blood thinners or who have any heart problems, or people taking other potassium supplements.

When taken internally or when used on the skin, Yarrow will cause the skin to become photosensitive and can make you very susceptible to sunburn.

Yarrow can also cause a rash similar to poison ivy.

Yarrow is a diaphoretic or will induce sweating. Yarrow encourages better circulation in the small veins and capillaries. It should not be used if tumors or cancers are present or suspected. Many cancer treatments strive to kill off cancers by reducing the blood supply to them. The use of Yarrow in this situation would be counterproductive and possibly dangerous.

Doctrine of signatures

The leaves of the Yarrow plant are so finely dissected that they look like many tiny leaves on 1 stalk, making the leaf look like a serrated knife. It is associated with things that "cut to the bone" and is best known as a wound healer. Yarrow is also known as "Warrior Weed." It was used on shields of warriors and as a talisman for hunters, carpenters, or anything where sharp objects are used. The leaves tell us that it is good for bleeding wounds and in fact is used to "get the blood moving."

The white flowers are in flat clusters and show us they are used for bones, teeth, and connective tissue.

Fevers

A tea made in equal parts of Yarrow and Wintergreen is good to bring down fevers. To make it, use a palmful of the herb mixture to 1 cup boiling water and allow to steep. Use 1 cup a day for a maximum of 2 days. Yarrow helps to induce sweating to bring down fever.

Bleeding wounds, nosebleeds, hemorrhages, bleeding piles

Yarrow's main action is to get blood moving. It attracts blood and coagulants to the area; that reduces the clotting time of the blood. It used to be known as "nosebleed," because it stops even severe nose bleeding when fresh leaves are packed in the nose or between the upper gum and lip.

For most external bleeding problems, a compress of the fresh or dried leaves or a compress of the leaf tea will reduce the clotting time of the blood. A cool tea of Yarrow is also excellent for wounds, hemorrhages, and to shrink hemorrhoids.

Urinary tract, uremic poisoning, kidney stones, or bladder infections

A tea or tincture is good for treating blood in the urine and to disinfect the urinary tract. It is also taken as a blood purifier and for jaundice, measles, and uremic poisoning.

A tea is used after an attack of kidney stones or a bladder infection to help clean out any leftover debris. Drink 1 or 2 cups of tea per day for 5 to 7 days.

Tincture

Yarrow tincture is made by putting 1 cup of fresh Yarrow into 2 cups of a strong grain alcohol. Let it stand for 2 weeks, shaking twice a day. Strain and put into sterile jars. The Yarrow contains silacylates that deaden pain; it also has antibiotic properties. The tincture can be taken 3 to 5 drops under the tongue, three to four times per day, but should never be used for more than 14 days in a row. Be sure to read the **warnings** at the beginning of this chapter carefully before using Yarrow in any form.

Menses

Yarrow also regulates menstruation and is used for stopped menses to get stagnant blood moving again. Pregnant women or women who suspect that they might be pregnant should not use Yarrow. It can cause a spontaneous abortion and can kill both the mother and baby.

Yarrow will also expel gas from the stomach.

Eye compress

The whole plant can be ground up, placed in a pan with cold water, and allowed to steep for 10 minutes. Strain, dip a cloth into the liquid, and apply to the eye as a compress. This is used for bloodshot eyes, punctures of the eye, bleeding in the eye, bruising of the eye, pinkeye, and sties.

Electrolytes

In a 50/50 mixture with sage in a tea, it helps build up electrolytes. Electrolyte levels can fall as a result of severe vomiting or diarrhea or in people suffering from heat stroke. The tea is used at room temperature and is taken slowly and in small sips.

This can also be used for heat stroke in animals, particularly horses.

Skin, boils, jaundice, measles, acne

Yarrow used by itself as a tea is a good skin wash. However, it can make a person photosensitive (susceptible to sunburn) if used too often. A tea compress is good for infections, boils, or bad acne. You can also use a poultice of the fresh crushed leaves and apply directly to the skin. Cover the area if you are going to be in sunlight to avoid reactions.

Most skin problems are a result of an internal infection or a blood-borne problem. Yarrow acts as a blood purifier with antiviral and antibacterial properties. It is taken as a tea or tincture for jaundice, measles, boils, bad acne, and other skin diseases.

Bruises

Yarrow is used as a lukewarm tea compress or a compress of the smashed leaves. Yarrow is best for "bruises to the bone," bruises from bad falls, or deep bruises with a possible fracture, especially to the tailbone. Anytime there is a bad fall involved, Yarrow is the recommended compress for the bruises.

Strains, sprains, ligaments and joint pain, shin splints, bone spurs

A liniment is made by soaking Yarrow leaves and flowers in isopropyl alcohol for 7 days. This is for external use only. Rub into the skin over the area. Cover the area if you are going to be in the sunlight.

The liniment encourages better circulation in the small veins and capillaries. If larger veins are damaged or have low circulation, it allows the smaller veins to take over the work.

This should never be used on an area if tumors or cancers are present.

The liniment also has anti-inflammatory properties and is used for joint pain.

Teeth, gums, mumps, strep throat, colds, and flu

Yarrow is used as a gargle for mouth and throat problems. Use a strong tea, or add 1 to 3 eye droppers of tincture to a cup of warm water. This can be used as a gargle for mumps, strep throat, colds, or flu. It can be used as a mouth rinse for bleeding gums or loose teeth.

Bleeding from the lungs

Yarrow is burned and the smoke is inhaled deep into the lungs. Make a thimble-size plug of Yarrow leaves. Light them, then blow out the flame and allow the leaves to smolder. Inhale the smoke deeply. Repeat this two to three times per day for 4 to 5 days.

People with sensitive lungs can put the leaves in boiling water and inhale the steam. However, directly inhaling the smoke is more beneficial, so as soon as your lungs feel stronger, you should switch to the direct smoke.

Composting, gardens and insect repellent

Yarrow will help garden compost to rot faster. It is a natural activator for this and the concentrated solution is a good fertilizer. It is not necessary to use wild Yarrow for this. There are domestic varieties that can be purchased from nurseries that will work the same as the wild variety. Yarrow not only makes an attractive addition to your garden, it also has properties that repel insects by keeping aphids and thrips in check.

Yarrow can be made into a strong tea and used in a spray form to repel insects. It can cause a skin rash like poison ivy and should not be used on the skin. It can be used on plants and most pets to repel insects.

Edible

The leaves are high in potassium and the fresh young ones can be added to salads. The leaves can also be dried and used to make tea. Do not drink too much, though, as it also induces sweating. **Be sure to read the warnings at the beginning of this chapter carefully before ingesting Yarrow in any form.**

Divination

The Chinese used Yarrow stems to make I-Ching sticks that were used for divining or foretelling the future.

Birch

Black Birch, *Betula lenta*
White or Paper Birch, *Betula papyrifera*

The same chemical actions are found in white, black, sweet, or river Birch trees. It has layers of bark that resemble skin, but it is the inner bark that is medicinal. It is best gathered in the wintertime when the sap is flowing and the bark is thicker. There is less chance at this time of the bark having fungal or insect damage. As with other barks, it is best gathered when the first days of 40°F or higher weather makes the sap rise. This timing varies according to droughts and is dependent on water levels and also on phases of the moon. The bark comes off easier if there is a full moon or close to the full moon as the moon is coming up. See the instructions on tree barking and alternatives to barking in the section "Barking trees," page 20 if you are not experienced.

Doctrine of signatures
The signature of this plant is the skin like layers of the bark. This shows that the tea made from the inner bark is good for skin problems.

Caution: The Birch water will stain the bath tub and any porous containers. Fiberglass tubs and showers can be stained permanently, so use caution.

Birch trees should not be planted near a house. They hold water and during a full moon when the water is up in the tree, it will attract lightning.

Skin—dermatitis, rashes, thin skin in elderly, stings, bites, burns, acne, hemorrhoids
The oils found in Birch bark are very similar to those found in human skin. This makes it very soothing to rough, itchy, and sensitive skin when made into a water-based wash. It is used externally to ease skin problems.

An 8- x 8-inch square of inner bark is torn into ribbons and added to 2 quarts of boiling water. Remove it from the heat, and let it steep for about 1 hour or until the water turns a light burgundy to rose color. There will be an oil slick on the top of the water from the resins in the bark that should be kept with the water. When straining the bark from the water, use a large-pored strainer that allows the oils to remain but

filters out the bark. The usual paper towel or coffee filter will be too fine to allow this.

The Birch water is used as a skin wash for any type of rash, dermatitis, insect bite, or sting. It is also used as a wash for sunburn and hemorrhoids. It is good for cradle cap in children or dandruff and scaly scalps of any kind. It is also useful on dogs with mange or dry skin problems and sebaceous adenitis symptoms of itching and rough scaly skin even resulting in hair loss. The water can be used by both men and women as an aftershave, including sensitive skin on the face, underarms, and legs. It is used on elderly people who develop thin, paper-like skin. It is used once a month on invalids and the elderly as a preventative to keep the skin toned. It can be used for poison ivy and other itchy rashes.

To apply to skin problems, soak a clean, white cloth in the warm or cold bark water. Be sure there is no detergent residue on the cloth by soaking it in several rinses of hot water until no soap residue can be seen in the rinse water. New cloth should always be washed before using because of chemicals used in cloth sizing. The clean cloth should be soaked in the Birch bark water and then applied to the skin. Allow the liquid to absorb into the skin for at least 3 to 5 minutes. This should be done three times a day for severe skin or scalp problems. As an aftershave, it should be used only after shaving.

For severe poison ivy, use Sweet Leaf tea as a compress followed by cool soaks with birch water. This will alleviate symptoms quickly and take away redness and itching immediately.

Sedative, diuretic, PMS and menses, sciatica

The leaves and bark are made into a tea together, using about 40 leaves and a 4 x 4 inch square of bark in 2 quarts of boiling water. In this case, the leaves and bark are boiled in the water for about 5 minutes before removing it from the heat. This tea is used internally in 1-cup doses as a mild calmative and diuretic. It is used to induce sleep and calm stress and is very good during menses and for PMS. The tea also is taken to calm the lower back nerves during bouts of sciatica.

Muscle regrowth

Serious muscle damage should only be treated by a trained professional. Untrained attempts to help can often cause more harm than good. This is another case of the need to preserve the knowledge but not wanting people to go around trying this on their own. It is also a good example of 3 herbs being mixed together and the resulting medicine not having the effects that you would expect from studying the

effects of the 3 ingredients. (See the "Beware of mixing herbs" section in the chapter "Some Words of Caution.")

A mixture of Sassafras, Ginseng, and Birch is used for muscle regrowth, even where the muscle has been severed. The detailed recipe is shown under Sassafras, but I will not discuss the actual treatment.

Miscellaneous

Birch bark is used by many cultures to weave baskets and form boxes and containers. The bark will repel insects, making it good for storage containers. The bark can also be easily carved or chewed for decoration, and fancy boxes are often adorned with dyed grasses or quills.

The pliable bark is famous for being used to make canoes. It makes a very lightweight and maneuverable boat, but they do not do well in rough water or rocky streams. A heavier bark, such as Tulip Poplar, was used for cargo and rough water travel.

A red dye is made from white Birch inner bark, Red Osier, Dogwood, Oak, and ashes from Cedar bark.

Food

The sap can be gathered in spring and made into syrup just as with Maple trees. Sap from Black Birch is sweeter than White Birch.

The sap can also be made into a beer.

Catkins, the little birch tails that get on it when it is breeding, can be used to make a leavening that is like baking powder. First they are dried, then ground up and burnt into ashes. The ashes are used in cornmeal or Cattail cakes as a leavening agent. We take the cattail roots and grind it into flour to make cakes like cornmeal pancakes. See the pancake recipe under Cattail.

The inner bark can be eaten raw or boiled like noodles as an emergency food source in survival situations.

Boneset

Eupatorium perfoliatum

This plant has also been called Bonemend, because it was used primarily for mending broken bones and speeding the recovery time. A tea made of the leaves and blooms is very bitter tasting. It is our belief that this should never be mentioned when taking the plant for medicine. It is an insult to the plant to ask for its help and then complain about the taste or to blow on hot tea and complain that it is too hot. As with all plants, they should be considered sentient beings that deserve respect and do not want to be insulted. You must connect with the plants spiritually in addition to accepting their medicine.

Diet restrictions

When taking Boneset, you should stay away from dairy products, caffeine, and refined sugars. Dairy products include milk, cheese, yogurt, and ice cream. Eggs and butter are OK to eat. The oil content of butter keeps it from interfering with Boneset the way other dairy products do. Refined sugars also include candy, sweets, breads, and pastries that use refined sugars.

Doctrine of signatures

The leaves of Boneset are paired, with the base of each leaf closely wrapped around the stem, forming a cupped intersection. It looks like the stem is growing out of the center of the cup. (It uses this cup to trap water and the insects that come there to drink. It is a cousin to primitive plants, like the pitcher plant, that consume the insects and water for nourishment.) The smooth junction of the leaves and stem looks like a mending bone. Also, the flower color is an off-white that is close to bone in color. This indicates that the plant is useful for problems with bones and the skeletal system.

Boneset grows in low-lying, swampy, cold areas. This indicates that it is used for conditions where water is being held back, such as pneumonia, pleurisy, colds, and flu, especially where water or fluids are being held in the lungs, head, or ears.

Boneset tea is very bitter. This is a signature that the herb is good for treating liver problems and cleaning the liver.

Skeleton—bones, breaks, osteoporosis

Boneset is very high in digestible calcium, making it a very good herb to use when the body needs increased calcium to the bones and skeletal system. It is used as a treatment or preventative for osteoporosis and to speed up the healing process when recovering from broken bones.

For skeletal problems, Boneset is best used in a tea form or the dry herb taken in capsule form. In these two forms the digestible calcium is more easily absorbed by the body. A tincture is not recommended for these problems. Instead of taking a tincture, it is better to carry your own capsules for times when you can't make a tea, such as traveling or working. Refer to the section "Capsules and pills," page 36, for directions on making your own capsules.

To make Boneset tea, use 4 tablespoons of the crushed herb in 1 quart of boiled water, and steep for 45 minutes. Then strain the liquid from the herb, and store in the refrigerator in a sealed, airtight container. Dosages vary depending on whether it is being used as a preventative or if you have been diagnosed as having osteoporosis.

Boneset can be taken in low doses for long periods of time, but should be taken for 7 days and then not used for 3 days. This 7-on/3-off cycle can be repeated long term. Taking 3 days off of any herbal remedy allows the body time to rest and keeps your body from building up a resistance to the herb.

Boneset, when taken alone, will help recalcify the entire skeletal system and keep bones strong. It should always be taken with food to avoid indigestion and to enhance absorption of calcium into the system.

As a preventative for osteoporosis; take 1 capsule, two times a day, or 1 shot glass (1 ounce) of tea, three times a day. When traveling or working, a capsule can be substituted for the tea.

Osteoporosis treatment: If you have been diagnosed with osteoporosis, then a higher dosage is recommended. Take 2 capsules, three times a day, or drink 1 cup of tea, two times a day. When traveling or working, substitute 2 capsules for 1 cup of tea.

Fractures, broken bones: In the case of broken bones, you do not want to recalcify the entire skeletal system but instead focus the calcium on the break. To do this, a pinch of Lobelia is added to the tea or 1 dropper full of Lobelia tincture is added to 1 ounce of Boneset tincture. Lobelia is known as smart weed and is often used as an additive to other herbal formulas that need to be directed to a specific spot. In this case, Lobelia will search out the broken bone and direct the Boneset to that spot.

For a normal broken bone, drink 5 to 6 cups of a strong Boneset tea with Lobelia per day. If using a tincture, add 1 eye dropperful of Lobelia tincture to 1 ounce of Boneset tincture. This is taken 5 drops under the tongue, five times per day.

For hairline fractures of bones, compound fractures, or hard-to-heal fractures such as those of elderly people, people with osteoporosis and a fracture, or fractures in people with frail frames, use a mixture of Boneset tincture (½ ounce), Horsetail tincture (½ ounce), and 1 eye dropperful of Lobelia.

Flu, colds with congestion, pneumonia

Colds and flu range in severity from mild to severe and present a wide variety of symptoms. Check out several herbal remedies listed here for the one that matches your symptoms most closely.

For most normal colds and mild cases of flu, Boneset is taken by itself in a tincture form. The tincture is taken 3 drops under the tongue, three times per day.

For more severe colds and flu, it is better to use a strong Boneset tea, drinking 6 cups of tea per day. You can substitute tincture instead of tea but at an increased dosage of 5 drops under the tongue taken four times per day.

For colds and flu with a wet, racking cough with fluid or wetness in the lungs or pleurisy-like pains around the lungs, a mixture of Boneset and Pleurisy Root (a.k.a. Butterflyweed, *Asclepias tuberosa L.*) are used. Mix the tinctures equally using ½ ounce Boneset tincture and ½ ounce Pleurisy Root tincture. In mild cases, take 3 drops under the tongue, three times per day. For more severe cases, take 5 drops under the tongue, four times per day.

Warning: Do not mix Pleurisy Root and Goldenseal. This mixture can cause severe dehydration and possible death.

For severe colds and flu that are accompanied by a stuffy head and ears AND coughing up yellow phlegm with fluids in the lungs and hot flashes of fever, a mixture of Boneset tincture and Goldenseal (a.k.a. Yellow Root, *Hydrastis canadensis L.*) tinctures are taken. Mix the tinctures equally using ½ ounce Boneset tincture and ½ ounce Goldenseal tincture. This should be taken 4 drops under the tongue, five times per day. In addition to the tincture, you should be drinking 6 cups of Sweet Leaf (a.k.a. Wild Bergamot, *Monarda fistulosa L.*) in tea form. You should also drink 8 to 10 glasses of fresh water per day. The water is very important, because the Goldenseal and Boneset tinctures

will dry out the fluids and mucous, making you dehydrate unless you drink additional water. The water rehydrates your body and helps flush toxins out of your system. The Goldenseal will help kill off both bacterial and viral infections, and in this case both are probably involved. The Sweet Leaf tea helps reduce fevers, promote rest, keep nausea away, and move infections through the kidneys and bowel and out of the body. The Goldenseal and Boneset are powerful expectorants that help clear the fluids and mucous out of the lungs. You may experience more coughing of phlegm. Be sure to get it out of the body—spit it out. Swallowing this is only returning the infection to the body and spreading it to the digestive system. Another side effect can be increased chills. This is normal, so keep an extra blanket to add when you are chilled and remove when you are hot. Get lots of rest and lots of water.

Induce vomiting

To induce vomiting, use a strong Boneset tea. Use an ice cold tea and chug (drink as fast as possible) 1 tall glass or as much of the glass as you can before results are seen. Be sure to be near a receptacle.

Laxative, cleaning the bowel and liver

If you are constipated, a strong tea of Boneset can be used as an explosive laxative. This should be used with caution on normally healthy people. If you are not constipated, it will not cause diarrhea. Use a warm to hot tea, and take 1 shot glassful (1 ounce). If this does not help within 2 hours, then take another 1-ounce dose.

This same strong Boneset tea is often used to clean the bowel and liver. Take 1 eye dropperful (1 tablespoon) twice a day for 1 week. Because Boneset is a bitter tonic, it has the signature for use as a liver tonic.

Muscles—relaxant and coughing

Coughing in this case is related to spasmodic coughing that is sometimes called break-bone coughing, so severe that ribs are bruised or broken. Sometimes when you break a rib, this same cough will develop. Boneset is taken in this case to relax the diaphragm and relieve the coughing. Take 1 ounce of warm tea every 15 minutes until the coughing stops. You can repeat this as often as needed, and each time it will take less tea to suppress the cough.

Boneset can also be made into a liniment by soaking the herb in isopropyl alcohol for 7 days. The liniment is used for sore muscles especially after spasms and convulsions or soreness that accompany the flu. The strained liniment is used externally only and applied liberally to sore areas of skin.

Reducing fevers

To reduce fevers when this is the only symptom, apply Boneset as a cold compress on the forehead and abdomen. Repeat this or refresh the compress to keep it cool until the fever breaks.

Night sweats

For night sweats, use 5 drops of Boneset tincture under the tongue before going to bed.

Food—calcium rich greens

Boneset herb is very bitter tasting, but it is an excellent source of digestible calcium. It mixes well with other flavors and is a great addition to vegetable soup or other soups and stews. I use about 1 teaspoon of dried herb per quart of soup. Crush the leaves, remove any stems or leaf stems, and add to the cooking soup. This is a really good addition during cold and flu season or when you are taking Boneset for osteoporosis or fractures.

Bull Thistle

Cirsium vulgare

I use some books on Western herbalism to verify Latin names and other common English names of plants. I was taught these plants by sight and sometimes by an Indian name that my teachers would use. When I started teaching these things to English-speaking people, I had to learn what they called them so we would have a common understanding of what plant we were talking about. I was amazed that this one wasn't listed under the medicinal plants, but I finally found it under edible plants.

Bull Thistle can be eaten when it is young if you snip off the stickers, but it seems like a lot of work for very little food. It is bitter, so you have to blanch it first by immersing it in boiling water for a minute, then take it out and cook it as a vegetable. This process draws the acids and latex out of it that make it bitter.

And then there are all those stickers and spines that need to be removed before you can cook and eat the greens. A bent willow stick can be used like tongs to hold the Bull Thistle while you pass it through a flame to singe off the stickers. It takes off the prickly ends but leaves the edible thorn base on the stem. It is high in iron, so I mention this as another pot green that you can use. The first year roots can also be eaten. After you peel them, you can eat them raw, boiled, or fried, or grind them into flour.

Doctrine of signatures

The essence of this plant is the hidden fire within. The outer part of the stem and the leaves are cool to the touch, but the pith in the center of the stem is warmer. This indicates a hidden fire quality. It has prickly winged stems and stinging needles on the leaves and stems that burn when they scratch you. This prickly pain is a signature that is sometimes associated with rheumatism. The bitterness of the leaves and root as they get older is a signature that it can be used to detoxify the liver and gall bladder.

Most of the medicinal uses deal with burning, stinging, fevers, and cleansing.

Skin—stings, bites, rashes, eruptions, ulcerations

A thick tea is made by simmering a large handful of roots in a quart of water for about 40 minutes. This is applied cold to skin problems

that are itching, such as poison ivy, insect bites, and bee stings. The mashed roots are used for skin ulcerations and to pull out stingers and slivers.

Liver, bladder, blood-purify and detoxify, cholesterol, blood pressure

The action of Bull Thistle on cleansing the liver helps regulate your cholesterol levels. This action also has the effect of lowering your blood pressure. For slightly high blood pressure due to high cholesterol levels, this is a better solution than stronger blood pressure medicines such as Goldenseal, which can lower the blood pressure too much or too quickly.

The whole plant of Bull Thistle—herb, stem, and root—is used to make a tincture. Take 3 drops under the tongue, four times per day, to clean the liver and gall bladder and as a blood purifier and strengthener. Bull Thistle is high in iron, which makes it a good blood tonic.

High metabolism

This is a condition when people have such a high rate of metabolism that within 10 to 15 minutes of eating, they break out in a feverish sweat. This is a signal of blocked energy internally, like an implosion fire. The fuel from eating that should nourish the body is blocked and has no place to go, so it builds up and manifests itself as a fever. The signature for this is the hidden fire within the Bull Thistle stems. A tincture made from the pulverized stems of Bull Thistle can correct this problem if taken over a period of 3 to 6 months. The tincture is taken 3 to 5 drops under the tongue, about 20 minutes before every meal.

Fevers

Another manifestation of the hidden fire within is a fever. Use 1 ounce of fresh stems with the stickers to 1 quart of boiled water, and steep for 45 minutes. Take 1 cup, drink it very slowly, and the fever should start to abate. For persistent fevers, a second cup of tea can be used, but because it contains high levels of silica, do not exceed 2 cups in a day.

A leaf and stem tea can also be used for fevers. Use ½ ounce of fresh herb and stem to 1 quart of boiled water, and steep for 45 minutes. The tea should be used as a compress on the stomach and forehead. Also, slowly drink a cup of the tea but do not exceed 2 cups in a day.

Rheumatism

The root of Bull Thistle is chopped up and added to isopropyl alcohol to make a liniment for rheumatism pain. This mixture should be shaken two times a day for 7 days before using. Then the alcohol is strained off and used externally by applying liberally onto painful areas.

Mouth and gum sores, cold sores

Make a tea using ½ ounce of the fresh herb to 1 quart of boiled water, and steep for 45 minutes. The tea can be stored in the refrigerator in an airtight container and used daily as a mouthwash. It will help relieve the pain and cure the infections associated with mouth and gum pains, including a sharp stabbing pain in the mouth, infected taste buds, and bites in the mouth or on the tongue. For cold sores, use the tea directly on the sores and also as a mouthwash.

Emergency water source

In an emergency or survival situation, the stem and root of Bull Thistle can be crushed and pressed to produce potable water.

Utility items, tools, drills, blow guns, and fire-making

The stalk of the Bull Thistle is very hard and contains a high level of silica. For its size it is comparable in strength to mahogany and is considered a hardwood suitable for fire-making. To use the stems for fire-making or for drills, you need to remove the thorns from the stem, making it smooth. First, the fresh stems are gathered and tied loosely in bundles of 8 to 10 stalks. Bundling them helps to keep them straight while they dry. As they dry, they harden. Then a hickory or oak stick is used to scrape off the barbs. It is then used as the bit shaft for a drill or the shaft of a fire-starting tool.

To create a fire-making shaft, Horsetail or Scouring Rush is used to sand down the stalks until they are very smooth on the sides and on the end where the stalk will be striking the fire board. This helps keep the end from splitting. It is important to get the sides very smooth, because in fire-making you would place the stalk between your palms and rub them vigorously together, turning the stalk quickly back and forth to create the friction on the fire board. If there are any rough spots left on the stalk, you will tear your hands up. This traditional fire-making technique is useful in survival situations, but is also important knowledge in many Native American communities where ceremonial fires must only be started in this traditional manner.

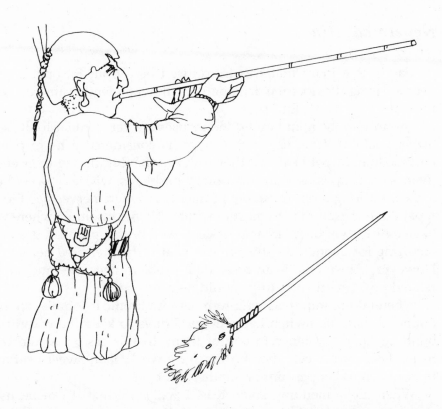

The fluff or thistle down is attached to the ends of a river cane (bamboo-like) splint with pine gum to make a dart for a blow gun. The blow gun is usually made of river cane and can be as much as 7 feet long.

Catnip

Nepeta cataria

Catnip is a plant that was introduced here from Europe. Native people, using the doctrine of signatures, independently came up with the same uses as the Europeans.

Catnip is in the mint family, and its uses are very similar to those of Sweet Leaf (*Monarda fistulosa*). Catnip, is considered a more potent nervine than Sweet Leaf, but they differ in the duration of their effectiveness. Catnip is used for temporary problems, whereas Sweet Leaf is used for long-term, recurring problems or where nerves need to be repaired. For example, if you suffer from chronic insomnia where you have a history of being unable to sleep well or this problem has been recurring for a long time, then Sweet Leaf is the preferred herbal tea. However, if insomnia is an occasional problem or a one-time stress-related problem, then Catnip should be used.

When taking mint teas long-term as for chronic insomnia, we recommend that you switch herbs every 7 days to keep the body from building up a resistance to one of them. In this case, I would take Sweet Leaf for a week, then Catnip for a week, then Sweet Leaf and then switch to Peppermint or another mint.

When recommending some teas, I will note that it can be used either hot or cold and have the same effects on the system. For Catnip, most of the uses below have a specific temperature recommendation where the herb has the best effect for that problem. This should be followed whenever noted.

Doctrine of signatures

The signatures that identify most nerve medicines can be seen in Catnip also. This includes the squared, purple stems, purple flowers, and paired, serrated leaves that indicate the balancing of frayed nerves. The balancing effect is also indicated by the fact that Catnip grows best in a balance of partial sun and partial shade. The cool taste and cool places where it likes to grow in indirect sunlight indicate that it has a cooling effect on fevers.

Trickster medicine

Catnip is considered a "trickster medicine." Most people know of Catnip's effect on cats as a stimulant, but it has also become a popular remedy among people as a calmative tea. This is the plant's trick: in

106

cats the top herb is a stimulant and the root is a calmative. But in people, the opposite is true: the top herb is a calmative and the root is a stimulant.

Warning: In people, the root speeds up the production of adrenaline and, if incorrectly used, will become a hyperstimulant causing strong claustrophobia, hyperventilation, and aggression.

It should only be used by trained practitioners; used incorrectly it can bring on heart attacks in people with weak systems.

In past times, Catnip was used as an escape mechanism when you needed to distract your enemies to escape. It was slipped into their drinks or water and the hyperstimulation would cause high anxiety that led to fighting or possibly a heart attack, and in the confusion you could slip away.

Hyper-stimulant, heart attack emergency

This should only be used by a trained practitioner.

Before the days of nitroglycerin tablets and patches, the death rate from sudden heart attacks was much higher. Heart attacks are a serious medical emergency that should be addressed by a trained professional. This remedy is presented only to explore the depth of medical knowledge in Native American root doctoring and to help preserve that knowledge.

A tincture (or slurry, since this is very thick) is made by filling a container with ⅔ powdered Catnip root and ⅓ grain alcohol. The tincture needs to be shaken twice a day for 7 days and then strained. Only the alcohol portion is used. Obviously, since it takes 7 days to make, it was kept on hand by the root doctor for emergency calls. When a heart attack is suspected, there is usually a pain in the left arm that starts as a weak throbbing pain in the left hand and begins traveling up the arm with the pain growing more intense and becoming a strong burn-

ing pain as it nears the chest. When the pain is moving from the arm to the chest, the patient is given 3 drops of the tincture under the tongue. This is repeated every ½ hour until the heart rate returns to normal.

Convulsions

A strong tea of Catnip bloom and leaf is made by adding ½ ounce of dried herb to 2 quarts of boiled water. Allow the tea to steep for about 45 minutes. Then strain and store the liquid in the refrigerator in an airtight container.

When a person has gone into convulsions, they should be immersed in a cool bath as soon as possible. If a bath is not available, then use cool compresses on the forehead and abdomen. Add 1 quart of a strong tea of Catnip leaf and bloom to the bath, or use this as the compress. Save the herb from the strained tea, and use this as a compress on the palms of the hands and the soles of the feet. This draws out any fever with the convulsions. If the patient is able, then have them also drink a cup of the strong tea.

Flu and colds with fever, diaphoretic

Make a strong tea of the leaf and blooms of Catnip. Drink 3 to 4 cups per day for the duration of the flu symptoms. Use more (4 cups) until the fever breaks. When it does, you will be cold and clammy. Then cut back to 3 cups a day and continue taking this until the symptoms are gone. This same strong tea is used as a diaphoretic, to promote sweating.

Abdominal cramps from indigestion, menses, overexertion, false labor, Braxton-Hicks

Make 2 quarts of strong tea, and strain off about 1 pint to drink as a tea. The remaining mix of herb and tea should be used as a warm compress on the painful areas of the abdomen. Also drink a shot glass (1 ounce) of the tea every 15 minutes until the cramping leaves.

108

Food poisoning, infants—sour stomach, colic

For food poisoning in adults, use a warm leaf tea. Take 1 cup of tea every ½ hour until the symptoms go away.

When treating infants for sour stomach and colic, the dosage depends on the size of the child and ranges from ½ teaspoon for very small babies to 1 tablespoon for larger children. This is a mild tea and can be given every ½ hour until the stomach distress goes away.

Insomnia

Use 1 cup of hot mint tea before bedtime. Do not ingest any caffeine product after 4 PM or 6 to 8 hours before bedtime. This includes chocolate, coffee, tea, and soft drinks that have high caffeine contents.

Pregnancy—morning sickness

Use a shot glass (1 ounce) of warm tea every ½ hour until the nausea goes away. For some women, just inhaling the vapors of the hot tea is enough to ease the nausea.

Nerves—calming, depression, anxiety, hyperactivity

Mint teas have a balancing effect on the nerves. If you have mood swings from mild depression to mild anxiety or drowsiness and then hyperactivity, a mint tea may be helpful. As with other problems, severe mood swings and depression need to be addressed by a trained professional. Catnip tea can be taken as a nerve-balancing aid. As I mentioned earlier, if you are having these problems long-term, then Sweet Leaf (Wild Bergamot) is probably the better choice, but for short term problems, Catnip can be very helpful. It is also good to switch off from one mint tea to another every 7 days to prevent your body from building up a resistance to the herb's effectiveness.

Swelling

Catnip can be used for impact swelling from injuries, swollen joints, and edema or swelling in the legs. It is used as a poultice by making a strong tea but not straining it off. Use the lukewarm herb and liquid on swollen areas as a poultice, and leave it there for about 45 minutes. This treatment can be repeated as often as needed.

Expel worms

The flower tops are used, either fresh or dried. One tablespoon is added into food or taken in capsule form at every meal for 30 days.

The life cycle of some worms is 21 days, so it is important that you continue this dosage at every meal, every day, for at least 30 days to make sure all of the worms are killed off.

Checking for worms: Humans get worms just the same as cats and dogs. With animals and humans, the patient's eyes will become cloudy when worms are present. In cats and dogs, you will notice them scratching and licking at their anal area and rubbing themselves along the ground. In children, you will notice an unusual amount of scratching in this area too. In both animals and humans, too, when one gets worms, the other siblings need to be checked out and the healthy ones separated from the sick ones for 30 days to prevent spreading.

Back in the early days of adhesive tape, the old people would use it to check for worms in the kids by placing tape over their butts at night and leaving it there while they slept. In the morning, the tape would be checked for worms which were coming and going in the night and got stuck on the tape. A quick check of all the kids would let granny separate the healthy from the sick. The healthy ones would be sent to visit the nearby relatives for the month, while the sick ones were kept at home for doctoring.

Repel rats and mice

Catnip does not kill rodents but does drive them away. The fresh or dried herb is strewn around the floors and into corners, closets, and at the baseboards or any places where the rodents are likely to enter or nest.

Repel insects

As with rodents, Catnip does not kill insects but can be used to keep them away. A muslin bag is filled with Catnip and hung at the doors and windows where insects are likely to enter. A good mixture for this is equal parts of Catnip, Pennyroyal, and Tansy. As you pass by the bags, once a day squeeze it to crush the herb and release the scent and oils.

Cattail

Typha latifolia

Warning: The Cattail is God's filtering system for the water where they grow. The toxins in the water are gathered in the root system and retained there. If the water where they grow is not drinkable or is polluted, do not gather and use the Cattail for any food or medicine source. Do not gather them close to roads or where there is a danger of agricultural runoff such as chemical fertilizers, pesticides, and herbicides.

Also be aware that where there are Cattails there are probably snakes and other critters lurking in the dense root and stalk cover. Use a stick to chase out the critters before you get too close. On the other hand, if you are fishing, this is a favorite place for fish to hide.

The root is the main medicinal part of the plant but the leaves, pollen, and cattail heads have uses as foods, utility items, and building materials. The roots are dug up usually out of the mud below standing water. If you are careful and start digging up around the edge of the stand of Cattail, then you can often lift them up like a carpet because the roots will be so intertwined. As you gather the roots, place them in a container of water to keep them wet until you are ready to take them ashore and husk them. The husk needs to be removed before using the root, but if it is allowed to dry out, it sets up like concrete and you will never get the husk off. As with all roots, it is easier to gather them when the moon is down.

Doctrine of signatures

The center of the root and the center of the crown or top is very woody and will break into splinters. This is a signature that it will draw out splinters and also that it can be used on anything where you need to draw out from the center, such as boils and carbuncles.

Anything with a white, starchy root is useful for drawing and pulling out splinters, stingers, and for snake bites. The leaves are very sharp edged and will cut you if you draw them across the skin, and the top is shaped like a spike. This signature shows that it is used for cuts and wounds, especially puncture wounds.

Skin—boils, carbuncles, stings, snakebites, insect bites

The raw roots of Cattails are crushed and used as a poultice for a drawing agent to pull out stingers, splinters, and slivers. It can also be used to draw out poisons from snake, insect, or spider bites. It is also used for boils and carbuncles where you want to draw infection out from the center.

Antiseptic—cuts, bleeding, pain, toothaches

There is a sticky spot at the base of each leaf that contains a slime that is applied to cuts and abrasions. It will also help stop bleeding and lessen pain. It can be used on toothaches to lessen the pain.

The fluff from the crown can be used as a coagulant for severe cuts and bleeding wounds, especially puncture wounds. It is not antibacterial but will help seal up a wound and help the area form a scab.

Diaper rash, feminine protection

The fluff from the crown of a mature Cattail is gathered, cleaned, and saved for use as an absorbent padding for diapers and for feminine protection padding in women's breechcloths. To prevent chafing and diaper rash, Club Moss (*Lycopodium*) is dried, powdered, and mixed with the fluff and used like baby powder. The Club Moss is antibacterial and provides medicated protection, while the Cattail fluff is absorbent and draws moisture away from the skin.

Food

Most parts of the Cattail are edible if you know what time of the year to gather each part. You can grow ten times as much food on the same amount of land by growing Cattails instead of potatoes.

In the early spring when the Cattail shoots are 6 to 8 inches tall, cut

off the shoots at ground level. In about 2 weeks, another shoot will appear but, don't harvest these more than twice from the same plant or it will kill it. The tender young shoots can be eaten raw and in salads. They smell and taste like crisp cucumbers. They can also be cooked, but they become slimy, like okra.

Later in spring, the head or crown begins to form. They are hard and thin but can be steamed and eaten like corn on the cob. The center is a woody pith that is not eaten.

In middle to late spring, a spike forms above the crown that is covered with pollen. The pollen is high in nutritional value and vitamins, making it a valuable food source. It is especially good for convalescents and people with digestive problems when cooked as a gruel like oatmeal.

The pollen is collected by cupping your hand and dragging it over the spike. Empty your handful of pollen into a container, but before moving on, rub your hand over the brown fuzzy crown. The excess pollen on your hand will fertilize the minuscule brown flowers that are the fuzz and clean off your hands. A 10 x 10 foot patch of Cattails will yield enough pollen to make pancakes for 4 people.

The collected pollen is then dried in the sun and ground into flour. It can be used alone or mixed with other natural flours, including a flour made from the Cattail root. The flour is used to make pancakes, as a breading for fish and meats, as a thickening agent for stews and sauces, or cooked into a gruel and eaten like oatmeal.

From mid-summer through late fall, the roots are harvested. For a food source it is better to dig up one plant at a time and just remove the small, white "pearls" or corms that grow along the root stalk. Then replace the larger root and plant to ensure further growth. The corms can be eaten raw, sliced into salads, or cooked like potatoes.

The roots have a woody pith center that can't be eaten but the outside section is quite good, as are the corms. They need to be husked, minced, dried, and then ground up to make a flour that stores very well. This can be mixed with the finer pollen flour to give it more texture.

In the winter, the easiest way to find survival food is to raid a muskrat den. If you gently remove the top of the muskrat den, which looks like a thatched hut, inside you will find up to 5 different kinds of medicines and 4 or 5 different kinds of edible roots. Cattail roots, Calamus roots, and several kinds of water lily bulbs are the most common goodies found in the dens. Anything that the little muskrats eat will not be poisonous to humans. Be sure to leave enough food for the muskrats, and they will continue to refill your secret storage bin for you.

Tools—torches, household items, housing

The head or crown of the Cattail can be soaked in tallow and used as a torch.

The fluff from inside the mature head is cleaned, dried, and used as stuffing for dolls, pillows, and comforters.

The long leaves can be woven into mats, rugs, clothing, and housing.

In the early 1990s, I was invited to Kentucky where a group of young boys wanted to build a clubhouse but didn't really have any money to put into building materials. We decided on a Cattail lodge made with a substructure of saplings and covered with woven Cattail mats. The final structure was 38 feet in diameter and about 12 feet tall in the center. When finished, it looked like a big inverted basket. In the center was a 6-foot fire pit that provided heat and cooking space. It would comfortably sleep about 15 kids plus their adult supervisors and all their camping gear and supplies.

It was not only great fun for the kids and adults, but a real learning experience as well. A core group of 6 was there every day to help with building, and the others came and helped whenever they could. It took us about 2 weeks to get the lodge completely finished, but some of us were staying there overnight after the first week. I do a workshop to teach these building techniques to adults, but this was the first one I had ever done that was this big.

The kids learned to gather the Cattails, 16 short-bed pick-up truck loads piled as high as they could be piled. Then they learned how to build a loom in the woods and string the warp threads with twine. The loom was big enough to allow them to weave a 12-foot-long mat from the Cattail leaves and stalks. After the first few tries, they could weave one of these mats in about 20 minutes using 3 people to run the loom. The mats were then placed in overlapping layers on a strong frame made of saplings.

In the end, they had a sturdy clubhouse with heat and plenty of room for their activities and sleepovers. It requires maintenance every year, and sometimes special attention after bad storms or ice storms, but it is easily repaired by making a few new mats or adding saplings for any damage to the frame.

We also learned that nothing will draw more attention from neighbors and passersby than a bunch of Indians building a thatch house in your side yard!

CheRRy

Black Cherry, *Prunus serotina*
Chokecherry, *Prunus virginiana*

Wild and domestic cherries and chokecherries can all be used in the same way.

Warning: Cherry leaves and pits are two of the most poisonous things on the continent next to water hemlock. Cherry leaves and the inner part of the pit of the fruit are loaded with cyanide. The wilted leaves are especially poisonous, because the cyanide is concentrated, but the fresh leaves are poisonous as well. Some natural low levels of cyanide can be tolerated by the body, but a small amount of the leaves can contain enough cyanide to cause death.

Cyanide can be found in our environment and in the foods that we eat. These natural and so-called acceptable levels or normal levels of cyanide accumulate in the fatty tissues in the body, and the body does not get rid of it. High amounts of cyanide are found in lakes and streams that are fed by the runoff from metal ore mines, especially gold and silver mines, where it seeps into the ground water. Be very careful in drinking water from areas near current or old mines.

There are herbal or dietary detoxification methods that will help expel cyanide from the body. Dandelion greens and roots work well when taken as a tea, eaten as food, or taken as herbal capsules.

Doctrine of signatures

The bark is the main part of the Cherry tree that is used for medicine. It looks like rough, irritated skin, smooth in spots with bumps and welts and has a reddish tint. This is its signature for use on skin problems and dermatitis. The tree shape and branch structure look like inverted bronchial tubes that are red and rough. This signature shows us that it is good for bronchitis and sore throats.

Throat and lungs—sore throat, bronchitis

A tea is made by using 1 ounce of the shaved bark to 2 quarts of boiled water. For sore or scratchy throats, add honey to the tea to coat the throat. Do not drink any fluids for at least 30 minutes after taking a cough remedy to allow time to coat and relieve the irritation in the throat. The tea is good for hard roaring coughs and was used during

whooping cough epidemics. It also soothes the throat and upper respiratory system during bronchitis.

This tea is the basis for the idea of cherry-flavored cough drops and cough medicines, but today many of these use artificial flavoring to get the cherry taste without the benefits.

Skin—rashes, dermatitis, acne, boils, eczema, psoriasis, bed sores, diaper rash, athlete's foot

A strong bark tea is made by shredding a 4 x 4 inch piece of bark into 1 quart of boiled water and allowing it to steep for 45 minutes. The bark tea should be used as a compress to soak the areas with skin problems. It can be used as either a warm or cold compress.

For athlete's foot, use a warm foot bath to soak your feet.

The tea is an astringent and can be very drying to the skin especially when using long-term for athlete's foot. If drying is a problem, then follow up with a moisturizing lotion to revitalize the skin.

Food

The fruit of the Black Cherry and chokecherry can be used as a flavorful food or beverage and dried for long-term storage. The sweet/tart taste is good for deserts, toppings, breads, beverages, and making wine.

The fruit can be easily harvested by shaking the branches and letting the ripe fruit fall into sheets or tarps on the ground. Be sure to remove all leaves, stems, and pits before using.

Dandelion

Taraxacum officinale

It makes me crazy that people spend millions of dollars a year to kill off the Dandelions in their yards by applying toxic chemicals. In a way, the joke is on them because the Dandelion's job in nature is to rid the ground of toxins and pollution. If their yards were healthy, had a balanced pH level, and pollution was controlled, they probably wouldn't have Dandelions. By spraying toxins they may kill off the current batch of "troublesome weeds," but they are inviting more to come over and help out with the cleanup. It becomes a crazy circle that is sort of funny when you think about it.

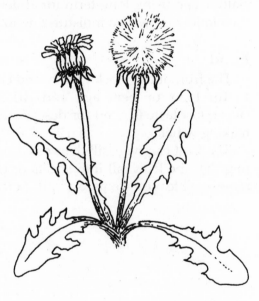

I actually recommend that a combination of Dandelion and Yarrow be used for a compost that will make your soil more healthy. It has a medicinal effect that doctors your lawn against toxins. You should put the compost on your lawn in the spring and leave it there for the summer season. In the fall, rake it all up and get it off of your property, because all of the toxins will be sucked up into the old mulch. It is like putting a poultice on your yard.

Doctrine of signatures

The yellow flower and the bitterness of the leaves and roots as they get older are signatures that Dandelions can be used to detoxify the liver and gall bladder.

Generally, Dandelions don't grow on healthy ground, indicating that they are used to revitalize the soil.

The hollow, tube-like stems and the yellow flower indicate that the plant is used in treating kidney and urinary tract problems.

The acidic taste of the roots tells us that it is good for stomach acid problems like heartburn and indigestion.

Eating too many Dandelion greens can cause indigestion and diarrhea. This is a signature too. We say that when you overuse an herb, it will cause what it cures. In this case, turn that around and say that in a smaller dose it will cure what it causes.

No leaf tea or boiled greens

The leaves of the Dandelion are high in iron, vitamin A, and vitamin C. To retain the nutritional and medicinal value, they should be eaten raw as a mixed salad green, fried as a mixed green, or mixed with mashed potatoes and fried like fritters. Do not boil the leaves for a tea or for pot greens because they lose almost all of their nutrients and medicinal value. The leaves must be used fresh and not dried for the same reason.

Blood—anemia, blood tonic

The fresh leaves, raw or fried, are high in iron and vitamins and are used for treating weak blood and anemia. They should be eaten daily but in small portions since they can cause diarrhea. Use them as part of a mixed salad or mixed in other fried foods such as fried mashed potatoes, fried breads, or mixed greens that are fried and not boiled.

Liver—detoxify, jaundice, hepatitis, cholesterol, blood pressure

The fresh greens or powdered root will work to detoxify the liver. The fresh or dried root is powdered, and ½ tablespoon is mixed into food at each meal. The powdered root can be made into a tea, but this is very bitter. The powdered root can be taken in capsules at meal time. Before capsules were invented, the powdered root was mixed with an equal part of flour. Then enough water was added to make the mixture into a thick dough. This was formed into pill-size balls that could be taken with meals.

Kidney—urinary tract

The powdered root is taken to increase the urine flow when there are kidney or urinary tract problems. It also has slight laxative properties.

Skin—eczema, dermatitis, scurvy

The fresh leaves, flowers, and stems are eaten raw or fried for skin problems and scurvy. The high vitamin C content is excellent for the mouth sores and skin problems of scurvy and for eczema and other itchy, scaly patches of skin.

It is helpful to add Dandelions to the diet of rabbits and other grazing animals who suffer from skin problems.

Skin—warts

The sap or latex from the stem of Dandelions is applied directly to warts several times a day. You should also treat the blood by using Dandelion root at the same time as treating the wart. See the directions above for treating the blood.

Digestive—heartburn, indigestion

For intense heartburn or indigestion where nothing else seems to work, use a very strong Dandelion root tea. Use ½ cup of minced root to 1 cup of boiled water, and steep it for 30 minutes. Then strain off the liquid and drink it down. It is very bitter but will work very quickly.

Food—greens, fritters, wine, jelly

For the best flavor, the leaves should be gathered before the plant flowers, and they will not be bitter. They are good in salads, as a mixed green, or on sandwiches.

The flowers can be used to make wine or jelly by boiling them in water and then straining off the liquid. Lemons or oranges can be added to the liquid for either wine or jelly to add a tangy flavor.

The flowers can also be eaten raw or in salads, but make a great fritter by dipping them in a tempura batter and deep-frying them.

The young roots can be sliced thin and boiled in 2 changes of water like potatoes, but this takes out the medicinal value. If this isn't a concern, then add a pinch of baking soda to the water to take away any bitter taste. The better choice is to sauté the slices in butter and seasoning.

The roots can be chopped up and dried for at least 2 days, then parched or roasted to a golden brown and used as a coffee substitute. In my opinion, as an avid coffee drinker, this is no substitute. But, as an herbal tea, it has good medicinal value and stores well in this dried and roasted form.

Dyes

The Dandelion root is boiled with alum to make a magenta or reddish-pink dye. When the root is boiled with iron, it will make a yellow/brown dye.

Field Horsetail/Scouring Rush

Field Horsetail, *Equisetum arvense*
Scouring Rush, *Equisetum hyemale*

These are two separate plants that look very different but have the same feel and are used interchangeably. The Scouring Rush is also called Greater Horsetail, and for this text we will refer to both of them as Horsetail. The Field Horsetail is shaped like a tiny pine tree with branches but without any needles or leaves. The Scouring Rush is a single straight stalk that has noticeable joints every 3 to 6 inches and has a bud-like pointed crown at the end of the stalk. Both have hollow stalks and the outside is ridged and very rough like an emery board or a scouring pad. This gives us the name Scouring Rush.

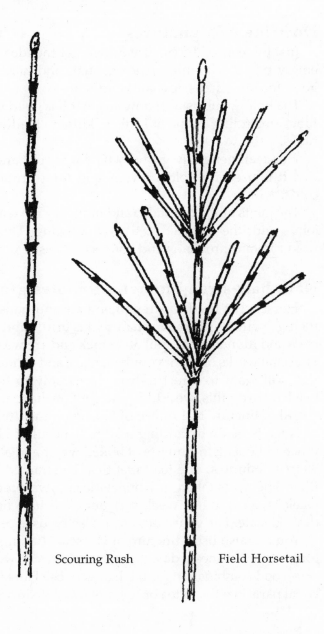

Scouring Rush Field Horsetail

Warning: Horsetail plants are 85% silica. Do not eat these at any time. Any teas or tinctures need to be strained twice through a fine filter, like a coffee filter. Do not use the tea or tincture for more than 1 week in any form. Ingesting something with this high a silica content would be like eating broken glass; it would tear up your insides and could lead to death.

Doctrine of signatures

Just by feeling the plant you will get the idea that it makes a good emery board. This high silica content and hard outer skin makes it good for fingernails, toenails, and hair.

The hollow tube stalk shows us that it is good for problems with the tubes, including bronchial tubes, kidney, bladder, and urinary tract tubes.

Horsetail generally grows where it is cold and wet. This indicates that it is used for colds, fevers, and lung problems associated with colds.

The joints along the stalk (and branches in Field Horsetail) look like joints with the connective tissues showing. This shows us that it is used for joint problems and connective tissue problem.

Nail, hair-strengthener, promotes growth

Horsetail is used to strengthen hair and nails and also encourage their growth. It is taken for hair that is brittle and breaks easily or split ends and for nails that split and crack and are weak. When taken alone, Horsetail works on all of your hair, nails, and connective tissues. Usually you will want to direct its properties only to the places where it is needed. To do this, we add a pinch of Lobelia to the tea or an eye dropperful of tincture to 1 ounce of Horsetail tincture.

A tea is made by adding a large handful of Horsetail stems and a pinch of Lobelia to 2 quarts of boiled water and allowing it to steep for 30 to 45 minutes. The tea must then be strained twice through a fine filter. The tea is taken in 1-ounce doses, two times a day, every other week (1 week on, 1 week off) until the hair or nails return to the desired state. For your hair, it can also be used as a hair rinse.

You can also use a tincture of Horsetail, taking it 5 drops under the tongue, three times a day, every other week (1 week on, 1 week off).

A good combination for the hair is to use Horsetail and Agrimony in equal parts in either a tea or tincture form according to the doses above.

Kidney, bladder, urinary tract—infections, incontinence

For infections in the urinary tract and kidneys or bladder the top part of the plant is used. A tincture is preferred for this, but a tea can be used. The tincture is taken 5 drops under the tongue, five times a day. If using a tea drink 6 to 8 cups per day. In either case, when you have a urinary tract infection, increase the amount of water that you drink to at least 8 to 10 glasses per day. If you do not like the taste of your tap water, explore bottled water but be sure it is not distilled water. Drinking distilled water will take minerals away from your bones and teeth that are normally absorbed from water. It should be spring, artesian, or bottled drinking water. You must increase the plain water intake. Other fluids do not count toward this 8 to 10 glasses, even teas, flavored waters, or juices.

Kidney, bladder—stones and gravel

For gravel or stones in the kidney, gall bladder, or urinary tract, you need to use Horsetail root. It can be used in tea or tincture form but it takes ½ ounce of the root to make either a tea or a tincture, and it can take 45 to 50 plants to get this much root. Scouring Rush has very small roots, and the Horsetail has even smaller roots. It is more economical to use the roots for a tincture, because the quart of liquid goes further as a tincture than as a tea. The dosage for a tincture is to take 10 drops under the tongue, every 15 minutes, until the initial pain is gone. Then reduce the dosage to 5 drops under the tongue, six to eight times a day for 2 weeks until the gravel is gone. In tea form, take 1 shot glass (1 ounce) as a first dose. Then take 1 tablespoon of the tea every 15 minutes until the pain is gone. Then reduce the dosage to ½ ounce of tea, four times a day, for 2 weeks until the gravel is gone.

Lungs, bronchial tubes, colds, flu, fevers

To help clear the lungs and bronchial tubes and for colds, flu, and fevers, a tea is preferred. Use the top part of the plant, the stems, and branches to make a tea using a handful of herb to 2 quarts of boiled water. Steep this for about 30 minutes and then strain twice through a fine filter. Drink 5 to 6 cups of tea per day, but do not continue taking this for more than 7 days. A tincture can be used but is not preferred. The tincture dosage is 4 drops under the tongue, four times per day; do not take for more than 7 days.

Connective tissues—joints, heart, and throughout the body

Whenever most people think of connective tissues, they think of the joints at the elbow and knees particularly. But connective tissues are found throughout the body. An example is the heart. People worry about cholesterol, blood flow, and healthy heart muscles, but even if you have good nerve and venous action in the heart and good muscle tone, poor connective tissue can cause serious problems. The problem is known as a quiet murmur of the heart. This is when the connective tissue is weak and, as the heart beats, it is actually tearing itself apart. It sounds like it is beating itself to death.

Horsetail is used to strengthen connective tissues throughout the body. A tea is preferred and it is taken 4 to 5 cups per day. A tincture is taken 4 drops under the tongue, four times per day.

Horsetail is used for broken bones and fractures when mixed in equal parts with Boneset and a pinch of Lobelia added to direct it to the injury (See "Boneset" on page 97 for details.) The Horsetail in this mixture helps repair the connective tissues in the joints where the break has occurred.

Bleeding—internal, excessive bleeding from wounds, heavy menstruation, bloody piles

For most bleeding problems that are centered internally, a root tea should be used. This includes internal bleeding from accidents, heavy menstruation, and bloody piles or hemorrhoids. A strong root tea is taken in 1 ounce doses, six times a day, but do not take for more than 7 days.

For piles or hemorrhoids, use the tea internally, and also apply it as a poultice or wash to the anal area when there is itching or irritation.

For external bleeding, Horsetail will help coagulate the blood from severe wounds where there is excessive bleeding. The dried or fresh stems are powdered and applied as a poultice over the open wound. Do not use this powder internally.

Mouthwash, gargle, oral infections, skin—acne, eczema

For an antiseptic mouthwash, use the whole plant of Horsetail, root and stems combined, to make a strong tea. This tea is swished around in the mouth or gargled but not swallowed; spit it out.

This same whole plant tea is used as a very warm, but not hot, compress on areas of the skin where there is problem acne, eczema, and

related skin problems. It should be left on the problem skin for 20 minutes and applied two times a day.

Insect repellent

Add 2 handfuls of Horsetail stem segments and 4 tablespoons of powdered orris root to 2 quarts of boiled water. Let it steep for 30 to 45 minutes. This tea can be used as a body spray to keep insects away. As a water-based spray, you can spray this around your eyes and ears without irritation. The tea will not last long at room temperature and will quickly develop a sour smell. To prevent souring, you can add 1 pint of Witch Hazel to the final strained tea, but do not spray this mixture in or near your eyes.

Tools—drill bits, household items, cleaners

The rough outer skin of the Horsetail plant makes it ideal for utility items that are used for sanding and scouring. It can be used fresh or dried as emery boards, sandpaper, and as a scouring pad or bundle. The scouring properties will not hurt non-stick surfaces copper, porcelain, or pottery. It works to draw rust and dirt out of porous materials and even removes rust stains from bathtubs.

A cleaning solvent can be made by using 1 quart of Horsetail stems with 2 quarts of water and letting it stand overnight. The next day you can strain off the liquid and place hard-to-clean items in it to soak out stains and grime.

Drill bits are made for the ends of Bull Thistle stem drill shafts. The Horsetail is powdered and pine resin is used to stick it to the drill shaft. First, dip the shaft in a little pine resin, and then roll it in the powdered Horsetail. This is best used after the hole is already started.

Medicinal Plants Index

Birch

Bark 21
Baskets 96
Canoes 96
Dog mange/itching skin . . 95
Dye 96
Food
 beer96
 emergency food 96
 leavening 96
 syrup 96
Menses 95
PMS 95
Muscle
 regrowth 70, 95, 96
 rejuvenation 13
Nerves
 diuretic 95
 sedative 95
 sleep 95
Skin
 acne 73
 cradle cap 95
 dandruff 95
 dermatitis 95
 hemorrhoids 95
 insect bite, or sting 95
 mange 95
 poison ivy 95
 rash 95
 sunburn 95

Bloodroot

Abdominal cramping 52
Charm 55
Dye 54
Hormones 36, 52
Hot flashes 53
Liver 53
Love potion55

Menses 52
Nose congestion 53
Paint 54
Skin 36
 absorbed through 53
 body hair 53
 facial hair 53
 skin painting 52
 warts 53
Teeth
 plaque build-up 53
 toothpowder 53, 54

Boneset

Bones 64, 97, 98, 99
Flu 50, 64, 97, 99, 101
Greens101
Laxative 100
Liver 97, 100
Lungs
 expectorant 100
 pleurisy 97, 99
 pneumonia 97, 99
Muscles 101
Night sweats 101
Osteoporosis . . 8, 36, 98, 101
Skin
 liniment 101
Vomiting 100

Bull Thistle

Bladder 103
Blood pressure 103
Blood tonic 103
Fever 103
Food 102
Gall bladder 102, 103
High metabolism 103
Liver 102, 103
Mouth and gum sores . . . 104

Rheumatism 102, 104
Skin
 rashes 102
 stings 102, 103
 ulcerations 102, 103
Tools
 blow guns 104, 105
 drill bits 125
 drills 104
 fire-making 104
Water source 104

Calamus
Accelerator 14, 67
Allergies 67
Arthritis 67
Congestion 67
Joints 67
Laryngitis 66
Muskrat food 114
Teething pains 66
Throat 65
Toothaches 66
Voice 65, 66

Catnip
Colic 109
Diaphoretic 108
Fever 106
Flu 50, 108
Food poisoning 109
Indigestion 108
Insects 110
Menses 108
Nerves
 balancing 106, 109
 calmative 106, 107
 convulsions 108
 depression 109
 heart attacks 107
 hyperstimulant 107
 insomnia 106, 109

Nerves (cont.)
 stimulant 106, 107
Pregnancy
 Braxton-Hicks 108
 morning sickness 109
Rats and mice 110
Swelling 109
Worms 109

Cattails
Bleeding 112
Building material 111
Feminine protection 112
Food 111
 breading fish/meats .. 114
 corms 114
 gruel 114
 leavening 96
 pancakes 114
 pollen 113
 shoots 113
 steamed crowns 113
 thickening 114
Skin
 boils 112
 carbuncles 112
 chaffing 112
 diaper rash 112
 insect bites 112
 stings 112
 splinters 112
Snakebites 112
Tools
 clothing 115
 mats 115
 rugs 115
 stuffing 115
 torches 115
Toothaches 112

Cherry

Food
 beverage117
 breads117
 deserts117
 toppings117
 wine117
Skin
 acne117
 athlete's foot117
 bed sores117
 boils117
 dermatitis116, 117
 diaper rash117
 eczema117
 psoriasis117
 rashes117
Throat and lungs
 bronchitis116
 coughs116
 sore throat116
 whooping cough117

Dandelion

Blood
 anemia119
 blood pressure119
 cholesterol119
 tonic119
Compost118
Diarrhea119
Dyes120
Food
 fritters119, 120
 iron119
 jelly120
 salad119, 120
 sauté120
 tea120
 vitamin A119
 vitamin C119
 wine120

Gall bladder118
Heartburn120
Indigestion119, 120
Kidney118, 119
Laxative119
Liver118
 detoxify119
 hepatitis119
 jaundice119
Skin
 animals120
 dermatitis119
 eczema119, 120
 scurvy119, 120
 warts120
Stomach acid118
Urinary tract118, 119

Echinacea

Blood
 blood cleanser58
Immune system
 AIDS59
 herpes59
 Lyme's disease58
Nerves
 burns59
 pain relief59
 sleeping aid59
 toothache59
Overdoses12
Skin
 abscesses58
 boils58
 burns59
 cancer, skin59
 itching59
 sores58
 stings58
 wounds58
Tumors59
Teeth53, 59

False Solomon's Seal

Bones 64
Constipation57
Diaphoretic 57
Digestive problems 57
Food
 appetite suppressant . . 64
 raw 57
 survival food 57
 tea 57
Headaches 37
Invisibility 57
Nerves
 anxiety 57
 calming babies 57
 depression 57, 64
 mood swings 57
 PMS 57
 tension headaches 57
 nervous tension 37
Nursing sensitivity 57
Rheumatism 57
Stomach ache 57

Field Horsetail/Scouring Rush

Bladder 122, 123
Bleeding
 internal 124
 menstruation 124
 piles 124
 wounds 124
Bones 124
Colds 122
Connective tissues 124
Fevers 122, 123
Fire-making 104
Flu 123
Gall bladder 123
Hair 122
Heart 124
Incontinence 123
Insect repellent 125

Joints 122, 124
Kidney 122, 123
Menstruation 124
Mouth
 gargle 124
 infections 124
 mouthwash 124
Nails 122
Respiratory system
 bronchial tubes . . 122, 123
 lungs 123
Skin
 acne 124
 eczema 124
Tools
 cleaners 125
 drill bits 125
 household items 125
Urinary infections 123

Sassafras

Arthritis 69
Blood
 blood clotting 69
 blood pressure 69
 blood thinner 68
 blood tonic 69
 bruises 69
 cholesterol 69
 fat in blood 69
 gout 69
 skin eruptions 69
Cooking
 filé gumbo 70
 meat tenderizer 70
 spice 70
Digestive system
 bowel problems 69
 diarrhea 69
 stomach aches 69
Eyes 70
Frostbite 68

Heart ailments 69
Hyperpyrexia 68
Hyperthermia 68
Kidney ailments 69
Liver ailments 69
Muscle regrowth . . 13, 70, 96
Rash 69
Rheumatism 69
Skin eruptions 69

Solomon's Seal
Arthritis 60
Blood
 arterial bleeding 62
 bleeding from wounds . 62
 blood sugar 61
 internal bleeding 62
 menses 62
Bones 61, 64
Carpal tunnel 61
Charm
 arthritis relief 60
 divert evil 60
 power over enemies . . . 60
Connective tissue 62
Depression 64
Digestive system
 bowel problems 61
 colon 61
 friendly bacteria 61
 indigestion 61
 laxative 61
Fallen arches 61
Fatigue 60
Flu 50, 64
Food
 appetite suppressant . . 64
 preservative 64
 sweet potato 64
Joints 60, 61
Lungs 64
Menses 62

Muscles 61
Ruptured disc 62
Snakebite 63
Spine 60
Stomach/Wolf Medicine . . 60
Tendons 61, 62
Wedding gift 64
Wounds 62

St. John's Wort
AIDS 73
Anti-inflammatory 73
Antibiotic 73
Antiviral 73
Blood
 blood thinning 71
 menstruation 71
Charm
 divert lightening 72
 storms dissipate 72
 ward off evil 72
 witches 72
Digestive system
 bladder ailments 73
 diarrhea 73
 dysentery 73
 worms 73
Eyes
 detached retina 71
 retinal bleeding 71
Menstruation 71
Nerves
 antidepressant 73
 anxiety 73
 depression 13, 71
 nerve damage 72
 SAD, cabin fever 73
 sedative 73
 tonic for menopause . . 73
Skin
 acne 72, 73
 bruises 72

Skin (cont.)
 burns 72
 cuts 72
 rashes 40
 ulcers 72
Sunlight sensitivity . . . 13, 71
Ulcers 72

Sweet Fern
Convulsions 76
Digestive system
 cramps 75
 diarrhea 75
 dysentery 75
 food poisoning 76
 intestinal cramping 75
 nervous stomach 76
Fever 74
Mouth
 gums 76
 periodontal disease 76
 sores 76
 teeth 76
 toothpaste 76
 tooth powder 87
Fly repellent 74
Scalp
 cradle cap 75
 hair and scalp rinse 74, 75
 itching 74
 scaly scalp 75

 acne 75
 bad smells 76
 boils 75
 cold sores 87
 fever blisters 87
 insect bites 75
 itching 75
 psoriasis 75
 rashes 75
 sunburn 75

Teeth
 gums 76
 periodontal disease 76
 sores 76
 teeth 76
 toothpaste 76
 tooth powder 87

Tansy
Dye 79
Eyes 79
Feet & ankles, swollen 78
Food
 pancakes 79
 sage substitute 79
Gout 78
Headaches 78
Insect repellent 78, 110
Insecticide 78
Menses 77
Varicose veins 79
Worms 77

Tulip Poplar
Anti-inflammatory 82
Antibiotic 82
Bear medicine 81
Fatigue 82
Heart
 blood tonic 81
 cholesterol 81
 tonic 81
Housing 81
Sutures/stitches 82
Utensils 81
 baskets 81
 canoes 81, 96
 rattles 81

Violet
Accelerator 14, 83
Antiseptic 83

Boils 83
Cancer
 breast 84
 cancer pain 84
 uterus 84
Carbuncles 83
Chapped lips 85
Cold sores 83, 85
Digestive system
 bladder 83
 diarrhea 84
 emetic 84
 morning sickness 84
 stomach pain 84
Food
 candy 85
 jelly 85
 poisonous look-alikes . . 85
 salad 85
 syrup 85
 vitamin A 85
Heart 83, 84
Nursing mothers 85
Prolapsed uterus 83
Respiratory system
 bronchial problems 83
 bronchitis 84
 coughs 84
 expectorant 84
 pleurisy 84
Skin lotion 85
Swollen glands 83
Varicose veins 85

Wild Bergamot

Bleeding gums 47
Digestion
 appendicitis 49
 bladder 48
 colic 47
 constipation 47
 diarrhea 47

Digestion (cont.)
 flatulence 47
 food poisoning 47
 halitosis 47
 indigestion 47

 kidney 48, 100
 lower digestive tract . . . 47
 mouth 47

 rectal itching 48
 salmonella 47
 stomach 47
 throat 47
 upper digestive tract . . . 47
 urinary tract 47
Ear
 ear infections 48
 fistulas 39
 Mineir's disease 48
 tinnitus 48
Fevers 46, 100
Flu 50, 64, 99
Frostbite 46
Hunting 51
Hypothermia 46
Love potion 50
Lung
 bird sickness 39, 40
 cough 47
 infection 40
 lung problems . . 39, 40, 64
 sore throats 50
 tuberculosis 39, 40
 upper respiratory 50
Menstrual cramps 47
Mouth & gum sores 47
Mouth/halitosis 47
Muscles 48, 51
Nerves
 anger calming 42, 43
 anxiety 41, 109

Nerves (cont.)
 chronic fatigue 51
 corpse sickness 43, 51
 damaged nerves 43
 depression 41, 43, 109
 dispel anger & violence . 38
 frayed nerves 40

 hyperactivity 42, 109
 insomnia 41
 pain 40
 passion 39

 severed nerves 43
 spirit 39
 spiritual feeling38
 spiritual fumigant 43
 stress 43, 51
 violence calming . . . 42, 43
Sacred Medicine 16, 39
Scar tissue 46
Sexual problems
 candidiasis 48
 diverticulitis 48
 gonorrhea 48
 Love Medicine 50
 syphilis 48
 vaginitis 48
 yeast infections 48
Skin
 anti-irritant 40
 astringent 40
 bee stings 40
 burns 40, 44, 45, 46
 dermatitis 40
 eczema 51
 poison ivy 40, 41, 51
 psoriasis 51
 rash 41, 51
 splinters or slivers 40
 stings 40
 sunburn 44, 45

Skin (cont.)
 wounds 44
Smoking 50
Soap 51
Soups50
Spiritual fumigant 43
 dispel anger & violence 38
 spirit 39
 spiritual feeling 38
Throat 47
Urinary infections 47

Wintergreen
Alcohol poisoning 86
Cold sores 86, 87
Fever blisters 87
Fevers 88, 89
Food
 fruits 88
 jam 88
 pancakes, fry bread, etc 88
 salads 88
 soups and stews 88
 spice88
 tea 88
 trailside snack 88
Food poisoning 86
Gout 86
Inflamed joints 86
Liver 86
Mouth sores 87
Muscles 86
Rheumatism 86
Throat
 mouth sores 87
 sore throat 87
 strep throat 87
 tongue burns 87
 tonsillitis 87
Tonsillitis 87
Tooth powder 87

Yarrow

Antibacterial 91
Antibiotic 90
Antiviral 91
Bladder infections 90
Blood
 anti-inflammatory 92
 bleeding from lungs . . . 92
 bleeding gums 92
 bleeding of the eye 91
Blood (cont.)
 bleeding piles 90
 bleeding wounds . . . 89, 90
 blood purifier 90
 bruises 91
 circulation 89, 92

 clotting 89, 90
 hemorrhages 90
 increasing blood flow . . 89
 jaundice 91
 nosebleeds 90
Boils 91
Bones 89, 92
Compost 93
Diaphoretic 89
Digestion
 diarrhea 91
 gas 91
 vomiting 91
Divination 93
Electrolytes 91
Eyes
 bleeding in the eye 91
 bloodshot eyes 91
 bruising of the eye 91
 pinkeye 91
 puncture 91
 sties 91
Fevers 88, 89
Flu 92

Food
 salad 93
 tea 93
Kidney stones 90
Heat stroke 91
Hemorrhoids 90
Insect repellent 93

Ligaments and joints
 connective tissue 89
 pain 92
 shin splints 92
 sprains 92
 strains 92
Lungs, bleeding from . . 92, 93
Measles 91
Menses 91
Mumps 92
Skin
 acne 91
 boils 91
 cuts 89
 jaundice 91
 skin wash 91
 sunburn 89, 91
 wounds 89, 90
Strep throat 92
Sweating 89
Talisman
 carpenters 89
 hunters 89
 warriors 89
Teeth 89, 92
Urinary tract
 bladder infections 90
 blood in urine 90
 kidney stones 90
 uremic poisoning 90
 urinary tract infection . . 90
Wounds 89, 90

Index By Symptom and Usage

A

Abdominal cramping 52
Accelerator 14, 67, 83
Acne .. 72, 73, 75, 91, 117, 124
AIDS 59, 73
Alcohol poisoning 86
Allergies 67
Angina 84
Antibacterial 91
Antibiotic 73, 82, 90
Anti-inflammatory . 73, 82, 92
Antiseptic 83
Antiviral 73, 91
Anxiety 41, 57, 73, 109
Appendicitis 49
Appetite suppressant 64
Arguments, avoiding 55
Arterial bleeding 62
Arthritis 60, 67, 69
Athlete's foot 117

B

Back 8, 61, 62, 67, 73, 95
Barking trees 20, 21, 22
Baskets 55, 81, 96
Bear medicine 81
Bed sores 117
Bee stings 40
Beer 96
Bird sickness 39, 40
Bladder 48, 73, 83,
 90, 103, 122, 123
Bladder ailments 73
Bladder infections 90
Bleeding
 arterial bleeding 62
 bleeding from lungs . 92, 93
 bleeding gums 92
 bleeding of the eye 91
 bleeding piles 90

Bleeding (cont.)
 bleeding, wounds 62, 89, 90
 coagulant 112
 internal bleeding .. 62, 124
 piles 124
 wounds 45, 58, 89,
 90, 124
Blood
 anemia 119
 anti-inflammatory 73, 82, 92
 blood cleanser 58
 blood clotting 69
 blood in urine 90
 blood pressure .. 8, 12, 14,
 69, 103, 119
 blood purifier 90
 blood sugar 61
 blood thinner 68, 71
 blood tonic ... 69, 103, 119
 bruises 69, 91
 cholesterol 69, 119
 circulation 89, 92
 clotting 89, 90
 fat in blood 69
 gout 69
 hemorrhages 90
 increasing blood flow .. 89
 jaundice 91
 nosebleeds 90
 skin eruptions 69
Blood cleanser 58
Blood pressure 8, 12, 14,
 69, 103, 119
Blood tonic 69, 103
Blow guns 104, 105
Boils 58, 75, 83, 91, 112, 117
Bones 48, 60, 61, 64, 89,
 91, 92, 97, 98, 99, 123, 124
Bread 87, 88, 117, 119
Breading fish/meats 114

Breast cancer 84
Bruises 69, 72, 91
Building material 81, 111
Burns 38, 40, 44, 45,
 46, 47, 59, 72, 87, 94

C
Cancer
 breast 84
 cancer, blood supply . . . 89
 cancer pain 84
 skin 59
 uterus 84
Candidiasis 48
Candy 66, 85, 97
Canoes 81, 96
Carbuncles 83, 112
Carpal tunnel 61
Carpenters 89
Chapped lips 85
Charm/Talisman
 arguments, avoiding . . . 55
 arthritis relief 60
 carpenters 89
 cooperation 55
 evil, diverting 60
 fishing 55
 gambling 55
 hunting 55, 89
 lightening, diverting . . . 72
 love potion 55
 power over enemies . . . 60
 storms dissipate 72
 ward off evil 72
 warriors 89
 witches 72
Cholesterol 69, 81, 119
Cleaners 125
Clothing 54, 79, 115
Colds 14, 65, 92, 97,
 99, 108, 122, 123
Cold sores 83, 85, 86, 87
Colic 45, 47, 109

Colon 61
Compost 93, 118
Connective tissues . . . 62, 124
Constipation 47, 57
Convulsions . . 46, 76, 101, 108
Cooperation 55
Corpse sickness 43, 51
Cough syrup 67, 84
Cradle cap 75, 95

D
Dandruff95
Depression 13, 41, 43, 57,
 64, 71, 109
Dermatitis 40, 95, 116, 117, 119
Diaper rash 112, 117
Diaphoretic 57, 89, 108
Diarrhea 47, 69, 73, 75,
 84, 91, 119
Digestive system
 appendicitis 49
 bladder 48, 73, 83, 90,
 103, 122, 123
 bowel problems 61, 69
 colon 61
 colic 47, 109
 constipation 47, 57
 cramps 75
 diarrhea 47, 69, 73, 75,
 84, 91, 119
 dysentery 73, 75
 emetic 84
 flatulence 47
 food poisoning 47, 76
 friendly bacteria 61
 halitosis 47
 indigestion . . . 47, 61, 108,
 119, 120
 intestinal cramping 75
 kidney . . . 48, 100, 118, 119,
 122, 123
Digestive system (cont.)
laxative 61, 100, 119

136

lower digestive tract . . . 47
morning sickness 84
mouth 47
nausea8, 47, 100, 109
nervous stomach 76
rectal itching 48
salmonella 47
stomach aches/pain 47, 69, 84
throat 47, 50, 65, 66,
 84, 87, 92, 116, 117
upper digestive tract . . . 47
urinary tract 47
vomiting 91, 100
worms 73, 77, 109
Diverticulitis 48
Divination 93
Dog mange/itching skin . . 95
Drill bits 125
Drills 104
Dye 54, 79, 96, 120
Dysentery 73, 75

E
Ear
 ear infections 48
 fistulas 39
 Mineir's disease 48
 tinnitus 48
Eczema . 51, 117, 119, 120, 124
Electrolytes 91
Emetic 84
Evil, diverting 60
Expectorant . . . 50, 67, 84, 100
Eyes 70, 79
 bleeding in the eye 91
 bloodshot eyes 91
 bruising of the eye 91
 detached retina 71
 pinkeye 91
 puncture 91
 retinal bleeding 71
 sties 91

F
Fallen arches 61
Fatigue 51, 60, 61, 82
Feet & ankles, swollen 78
Feminine protection 112
Fever 46, 74, 88, 89,
 100, 103, 106, 122, 123
Fever blisters 87
Filé gumbo 70
Fire-making 104
Fishing 55
Flu 14, 50, 64, 92, 97,
 99, 101, 108, 123
Fly repellent 74
Food
 alcohol poisoning 86
 appetite suppressant . . 64
 beer 96
 beverage 117
 bread 87, 88, 117, 119
 breading fish/meats . . 114
 candy 66, 85, 97
 corms, cattail 114
 deserts 117
 emergency food 96
 filé gumbo 70
 flour 102
 food poisoning . . . 86, 109
 fritters 119, 120
 fry bread, etc 88
 greens 85, 101, 102,
 116, 119, 120
 gruel 113, 114
 iron 102, 103, 119, 120
 jam 88
 jelly 85, 120
 leavening 96
 meat tenderizer 70
 pancakes . . . 79, 88, 96, 114
 poisonous look-alikes . . 85
 pollen, cattail 111, 113, 114
 preservative 32, 35, 64

Food (cont.)
 sage substitute 79
 salad 85, 88, 93, 113,
 114, 119, 120
 sauté, dandelion 120
 shoots, cattail 112, 113
 soups and stews ... 50, 70,
 88, 101
 spice 70, 88
 steamed crowns, cattail 113
 survival food 57
 sweet potato 64
 syrup 85, 96
 tea 57, 88, 93, 120
 thickening 70, 114
 thickening oil 35
 toppings 117
 trailside snack 88
 vitamin A 85, 119
 vitamin C 35, 119
 vitamin E 35
 wine 117, 120
 Wintergreen fruits 88
Food poisoning 47, 76, 86, 109
Fritters 119, 120
Frostbite 46, 68
Fry bread, etc 88

G
Gall bladder 47, 102, 103,
 118, 123
Gambling 55
Gonorrhea 48
Gout 69, 78, 86
Greens 85, 101, 102, 116,
 119, 120
Gruel 113, 114
Gums 47, 76, 84, 87, 104

H
Hair 28, 39, 53, 71, 74,
 75, 95, 122

Halitosis 47
Headaches 37, 57, 78
Heart
 angina 84
 blood tonic 81
 charm 55, 60
 cholesterol 69, 81, 119
 heart murmur 124
 heart tonic 69, 81
 medicines 12
 potassium and 89
 purple color and 39
 stroke 69, 81, 91
Heart attack 107
Heartburn 120
Heat stroke 91
Hemorrhoids 32, 33, 90,
 94, 95, 124
Herpes 59
High metabolism 103
Hormones 36, 52
Hot flashes 8, 53, 99
Housing 81
Hunting, animals 51, 55, 64, 89
Hunting, plants 23, 24
Hyperactivity 42, 109
Hyperpyrexia 68
Hyperstimulant 107
Hyperthermia 68
Hypothermia 46

I
Immune system
 AIDS 59, 73
 herpes 59
 Lyme's disease 58
Incontinence 123
Indigestion 47, 61, 108,
 119, 120
Insect repellent/insecticide 74,
 78, 93, 110, 125
Intestinal cramping 75
Invisibility 57

Iron102, 103, 119, 120
Itching 34, 48, 59, 74,
 75, 95, 103, 124

J
Jam88
Jaundice 90, 91, 119
Jelly85, 120
Joints 32, 60, 61, 62,
 67, 86, 92, 109, 122, 124

K
Kidney 47, 48, 69, 90,
 100, 118, 119, 122, 123

L
Laryngitis 66
Laxative 61, 100, 119
Leavening 96
Ligaments and joints
 connective tissue 89
 pain 92
 shin splints 92
 sprains 86, 92
 strains 86, 92
Lightening, diverting 72
Liver
 ailments 69, 86
 damage to 12
 detoxify 86, 97, 100,
 102, 103, 118, 119
 hepatitis 119
 jaundice 90, 91, 119
 sluggish 53
Love potion 50, 55
Lungs 64, 123
 bird sickness 39, 40
 bleeding from lungs . 92, 93
 bronchial problems 83
 bronchial tubes . . 122, 123
 bronchitis 84, 116
 congestion 67
 coughs 47, 84, 116

Lungs (cont.)
 expectorant 50, 67, 84, 100
 infection 40
 lung problems . . 39, 40, 64
 pleurisy 14, 84, 97, 99
 pneumonia . . 14, 67, 97, 99
 tuberculosis 39, 40
 upper respiratory 50
 whooping cough 117
Lyme's disease 58

M
Mange95
Mats115
Measles 91
Meat tenderizer 70
Menopause
 hot flashes 8, 53, 99
 tonic for 73
Menses . 52, 62, 77, 91, 95, 108
Menstrual cramps 47
Menstruation 71, 124
Mineir's disease 48
Morning sickness 84
Mouth
 gargle 124
 gums . . . 47, 76, 84, 87, 104
 halitosis 47
 infections 124
 mouth/gum sores . 87, 104
 mouthwash 124
 periodontal disease .47, 76,
 84, 104
 sores 76
 sore throats 50
 teeth 53, 54, 59, 66, 76,
 87, 89, 92, 112
 tooth powder 87
 toothpaste 76
Mumps 92
Muscles . . . 48, 51, 61, 86, 101
 regrowth . . . 13, 70, 95, 96

Muscles (cont.)
 rejuvenation 13
Muskrat food 114

N
Nails 122
Nausea 8, 47, 100, 109
Nerves
 anger calming . . . 38, 42, 43
 antidepressant 73
 anxiety 41, 57, 73, 109
 balancing 106, 109
 burns 38, 40, 44, 45,
 46, 47, 59, 72, 87, 94
 calmative 106, 107
 calming babies 57
 convulsions 76, 108
 corpse sickness 43, 51
 damaged nerves 43
 depression 13, 41, 43,
 57, 64, 71, 109
 dispel anger & violence . 38
 diuretic 95
 fatigue 51, 60, 61, 82
 frayed nerves 40
 heart attacks 107
 hyperactivity 42, 109
 hyperstimulant 107
 insomnia 41, 106, 109
 menopause, tonic for . . 73
 mood swings 57
 nerve damage 72
 nervous stomach 76
 nervous tension 37
 pain 20, 32, 40, 44,
 45, 46, 53, 57, 59, 61, 62,
 64, 66, 67, 83, 84, 85, 90,
 99, 104, 107, 108, 112, 123
 passion 39
 SAD, cabin fever 73
 sedative 73, 95
 severed nerves 43

Nerves (cont.)
 sleep 41, 48, 50,
 59, 95, 104, 115
 spirit 39
 spiritual feeling 38
 spiritual fumigant 43
 stimulant 106, 107
 stress 43, 51
 tension headaches 57
 violence calming . . . 42, 43
Night sweats 101
Nosebleeds 90
Nose congestion 53
Nursing mothers 85
Nursing sensitivity 57

O
Osteoporosis . . . 8, 36, 98, 101
Overdoses 12

P
Pain
 back 61, 67
 bladder 83
 Braxton-Hicks 108
 broken bones 64
 burns 44, 45, 46, 59
 cancer 84
 carpal tunnel 61, 62
 flu 64
 gall stones 123
 gum 104
 heart attack 107, 108
 inflicting 20
 joint 32, 90
 kidney stones 123
 ligaments 90
 lung 99
 menses 108
 muscle 32
 neck, back of 53

Pain (cont.)
 relief of 40, 57, 59,
 62, 90, 112
 rheumatism 102, 104
 skull 53
 stomach 84, 108
 teething 66
 toothache 59, 66, 112
 urinary tract 123
 varicose veins 85
Paint 54
Pancakes 79, 88, 96, 114
Passion 39
Periodontal disease47, 76,
 84, 104
Pinkeye 91
Pleurisy 14, 84, 97, 99
PMS 57, 95
Pneumonia 14, 67, 97, 99
Poison 15, 40, 47, 58,
 67, 76, 85, 86, 90, 109, 112,
 114, 116
Poison ivy 22, 40, 41,
 50, 51, 59, 75, 89, 93, 95,
 103
Poison oak 41, 50, 59
Poison sumac 41, 59
Potassium 89
Pregnancy
 Braxton-Hicks 108
 morning sickness . 84, 109
 nursing mothers 85
 prolapsed uterus 83
Preservative 32, 35, 64
Prolapsed uterus 83

R
Rats and mice 110
Rattles 81
Red rooted medicine 14
Respiratory system
 bronchial problems 83
 bronchitis 84

Respiratory system (cont.)
 coughs 84
 expectorant 84
 pleurisy 84
Rheumatism 57, 69, 86,
 102, 104
Rugs115
Ruptured disc 62

S
Sacred Medicine 16, 39
Sage substitute 79
Salad 85, 88, 93, 113,
 114, 119, 120
Salmonella 47
Scalp
 cradle cap 75
 hair and scalp rinse . 74, 75
 itching 74
 scaly scalp 75
Scar tissue 46
Sciatica 95
Scurvy 119, 120
Sexual problems
 AIDS 59, 73
 candidiasis 48
 diverticulitis 48
 gonorrhea 48
 Love Medicine 50, 55
 syphilis 48
 vaginitis 48
 yeast infections 48
Skin
 acne 72, 73, 75, 91, 117, 124
 abscesses 58
 absorbed through53
 animals 120
 anti-irritant 40
 astringent 40
 athlete's foot 117
 bad smells 76
 bed sores 117
 bee stings 40

Skin (cont.)

body hair 53
boils 58, 75, 83, 91, 112, 117
bruises 69, 72, 91
burns 40, 44, 45,
 46, 59, 72
cancer, skin 59
carbuncles 83, 112
chaffing 112
cold sores . . . 83, 85, 86, 87
cradle cap 95
cuts 72, 89
dandruff 95
dermatitis 40, 95, 116,
 117, 119
diaper rash 112, 117
eczema 51, 117, 119, 120, 124
facial hair 53
fever blisters 87
hemorrhoids 95
insect bite, or sting . 75, 95,
 112
itching 34, 48, 59, 74,
 75, 95, 103, 124
jaundice 91
liniment 101
lotion, skin 85
mange 95
poison ivy . . 40, 41, 51, 95
psoriasis 51, 75, 117
rashes 40, 41, 51, 69,
 75, 95, 102, 117
scar tissue 46
scurvy 119, 120
skin painting 52
skin wash 91
sores 58
splinters 40, 112
stings 10, 11, 23, 40,
 58, 95, 102
sunburn 44, 45, 75, 89, 91, 95
sunlight sensitivity . 13, 71

Skin (cont.)

ulcerations . . . 72, 102, 103
warts 53, 120
wounds . 44, 58, 89, 90, 124
Shin splints 92
Sleep 41, 48, 50, 59,
 95, 104, 115
Smoking 50
Snakebites 63, 112
Soap 51
Soups and stews . . . 50, 70, 88,
 101
Sunlight sensitivity . . . 13, 71
Spine 60
Spirit 39
Spiritual feeling 38
Spiritual fumigant 43
 dispel anger & violence . 38
 spirit 39
 spiritual feeling 38
Sprains 86, 92
Stings 10, 11, 23, 40,
 58, 95, 102
Stomach ache 57
Stomach acid 118
Stomach/Wolf Medicine . . 60
Strains 86, 92
Strep throat 87, 92
Stroke 69, 81, 91
Stuffing 115
Sunburn 44, 45, 75, 89,
 91, 95
Sunlight sensitivity . . . 13, 71
Sutures/stitches 82
Sweating 89
Swelling 109
Swollen glands 83
Syphilis 48
Syrup 85, 96

T
Talisman
 carpenters 89

Talisman (cont.)
 hunters 89
 warriors 89
Tea 57, 88, 93, 120
Teeth 53, 59, 76, 89, 92
 plaque build-up 53
 toothache 59, 66, 112
 toothpowder . . . 53, 54, 87
Teething pains 66
Tendons 61, 62
Thickening 70, 114
Thickening oil 35
Throat 47, 50, 65, 66,
 84, 87, 92, 116, 117
 mouth sores 87
 sore throat 87, 116
 strep throat 87, 92
 tongue burns 87
 tonsillitis 87
Tinnitus 48
Tongue burns 87
Tonsillitis 87
Tools
 blow guns 104, 105
 cleaners 125
 clothing 115
 drill bits 125
 drills 104
 fire-making 104
 household items 125
 mats 115
 rugs 115
 stuffing 115
 torches 115
Toothaches 59, 66, 112
Toothpaste 76
Tooth powder 53, 54, 87
Toppings 117
Torches 115
Trailside snack 88
Tuberculosis 39, 40
Tumors 59, 89, 92

U
Ulcers 72
Urinary tract
 bladder 73, 83, 90, 103,
 122, 123
 blood in urine 90
 incontinence 123
 kidney stones 90
 uremic poisoning 90
 urinary tract, general . . 118
 urinary tract infection . . 47,
 48, 90, 123
 urine flow 119
Utensils 26, 27, 81
Uterus 84

V
Vaginitis 48
Varicose veins 79, 85
Vitamin A 85, 119
Vitamin C 35, 119
Vitamin E 35
Voice 65, 66
Vomiting 91, 100

W
Warriors 89
Warts 53, 120
Water source 104
Wedding gift 64
White rooted medicine 14
Whooping cough 117
Wine 117, 120
Witches 72
Wolf Medicine 60
Worms . . . 21, 73, 77, 109, 110
Wounds . . . 44, 58, 89, 90, 124

Y
Yeast infections 48
Yellow/brown dye 120
Yellow rooted medicine . . . 14

MEN WHO RAPE
The Psychology of the Offender